To the members of
The Saturday Morning Drawing Club,
past and present,
who have each brought so much
joy, adventure and spirit to our club.

.

THE DRAWING CLUB

of

IMPROBABLE DREAMS

.

Cat Bennett

Published in 2015 by Findhorn Press

ISBN 978-1-84409-675-6

Printed and bound in China

Published by
Findhorn Press
117–121 High Street
Forres IV36 1AB, Scotland, UK
t +44(0)1309 690582
f +44(0)131 777 2711
e info@findhornpres.com
www.findhornpress.com

THE DRAWING CLUB

of

IMPROBABLE DREAMS

.

Cat Bennett

FINDHORN PRESS

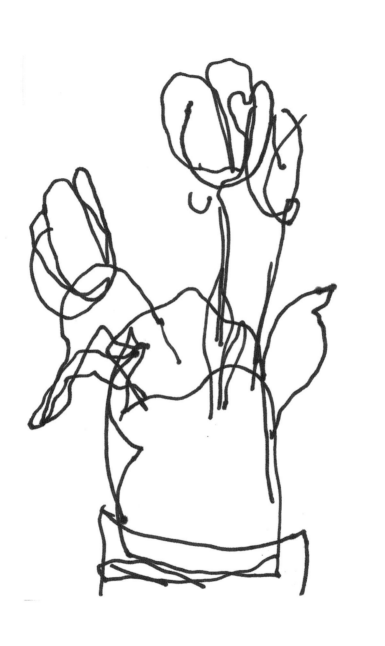

Contents

Preface

Ten years ago, I was invited to teach drawing at The Arsenal Center for the Arts, just outside Boston. Every week, I set up ways in which we could explore drawing without concern for predictable results. For instance, we'd draw with our eyes closed or paint with tree branches or make group drawings. The results were often improbable; that is they were more fantastic and cheering than we might have predicted. Some of us were rank beginners, some experienced artists. We all worked together and the bigger the chances we took, the more we learned to embrace ourselves just as we are and where we are. No small feat. We started seeing and doing more. People who hadn't drawn since childhood were soon making art, even having shows. Others began to change and grow their art in new ways. We began to expand our vision of what was possible for us as artists, and even in our lives. I know I did. And there was a lot of laughter. After some time working together, it became clear that we were more than an art class. We were a club, *The Saturday Morning Drawing Club*, a sanctuary for creative exploration, a place to gather and jump over the edge of our limited expectations.

This book shows how to start and run a drawing club in which we can nurture and grow our creative selves. Included are three 8-week session plans with exercises that will take a club through its first year. The first session is based on building drawing skills. In the second, we expand our creative thinking abilities by working in unusual ways and with different materials. In the third, we learn to let go of inhibition and ease into a sense of freedom. Instructions are also given for how to develop further exercises so a club can continue on.

All of the art in the book is by me or members of our club. Some is finished art; some is simple exploration in the form of pencil, charcoal, brush drawings and painted paper collages. As much as possible, I've used work from our recent sessions to illustrate some of the explorations we've made.

In our club, we've entertained the sometimes improbable dream that we can each find unique and brilliant ways to fulfill our creative desires. And we've so often slipped, like Alice, into Wonderland. Now, we invite you to join us.

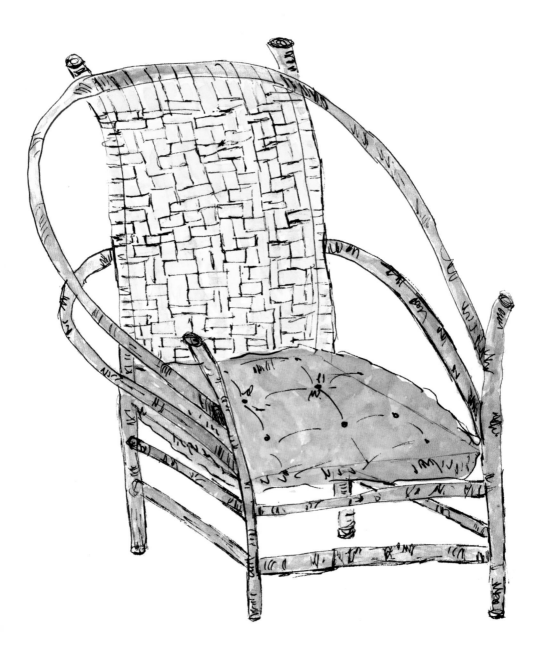

Introduction

"If you can see your path laid out in front of you step by step, you know it's not your path. Your own path you make with every step you take. That's why it's your path."

—Joseph Campbell

• • • • •

When I was asked to teach drawing to adults, I'd already been an illustrator for many years and made hundreds of drawings and paintings for newspapers, magazines, books and films. I'd studied art history at university but never been to art school, so when I began to teach I wasn't entirely sure how to proceed. All I had was a dream. I wanted others to be able to draw and make art so they might have a friend in art as I've had all my life; so they might have a place to reflect on the world around us in a visual way, to imagine and envision, and to make art. It seemed simple enough save for the fact that I didn't actually know much about teaching drawing. But I reassured myself that I'd been drawing for eight hours a day for years. I knew *something*.

The class was open to everyone, both beginners and more experienced artists. I wanted to believe that everyone can draw but I couldn't have said then for sure. I can now. Every single person who has come to our club, no matter how inexperienced or unsure, has learned to draw in a way that is distinctive, true and engaging. I especially hoped the beginners would feel welcome and that they would allow their desire to draw to overcome any trepidation. We're all uncertain when we do new things and, when we draw or make art, the evidence of any ineptitude is right there for us, and others, to see. It's true we have to get comfortable with the fact that drawing involves a learning process and we're okay just where we are, wherever that is on the learning curve.

There was no budget for models, so I thought we'd simply draw things like plants and still lives, clothes, shoes, chairs, whatever we had lying around. Then we could try drawing people too using photographs and possibly, if we were feeling a bit bold, we'd try drawing each other. When we haven't a lot of experience, drawing people is more daunting than potted plants. When we've drawn a lot, we may have another challenge—we may need to find our innocence and truth again. I wanted all of us, the beginners and

Sue Twombly—ink and watercolor drawing

the old hands, to feel free to explore freely without fear of mistakes. We've all been judged and graded all the way through school and on jobs. It can be so inhibiting and sometimes downright discouraging.

I did know that there's no shortcut or trick to drawing well. There's no special formula or at least none that will keep our eyes and hands alive and fresh. I wanted our drawings to be full of life and our own hand. I didn't want us to entertain the wishy-washy or aim for the overly earnest, prosaic study. I wanted to encourage mad bursts of awkwardness and for us each to gradually find our own truth in them. I had a lot of desires for the class, improbable dreams.

I knew that the only way to learn to draw well and be the artists we are is by working at it. It takes hours and hours, days, years. But every drawing matters; even the first can have genius. No one gets it all right from day one. As illustrator Maira Kalman said, "My secret for drawing is not a secret. It is sitting down and drawing." That's it. Practice, practice and, I would add, exploration. Trying things out and trying other things out. Progress is quicker and more interesting when we allow experimentation and its clumsiness and willingly, even consciously, make mistakes. We need to forget the carefulness that says we really ought to look good. I didn't know it at first but we were on a journey to embracing the whole of who we are, even our awkwardness.

So, we began. There were only five or six students in the first class, all women of middle age in that first session who had other careers. One had a higher degree in art, some had a regular art practice, and a couple hadn't drawn since childhood when lack of support or a wilting word stole their confidence. I decided to draw alongside everyone else, to be a fellow explorer and learner. I was excited to try drawing in new ways too and presumed there'd be less self-consciousness if I weren't peering over everyone's shoulders.

On the first morning, we drew plants. After working for an hour or so, we taped our drawings to the wall to look at them together. We'd all drawn the same plants but all the drawings had their own character. Most were a little wobbly but we learned our first great lesson—*each artist has a unique hand and way of seeing*. Even with different levels of skill, we could see *qualities* in each person's work. Some of us are tender, some quirky, some bold and incisive. I thought we were off to a great start!

Then, around the fourth week, one student broke down. She said she couldn't go on. "I'm afraid. I just can't do this." She told how a teacher long ago had made a casu-

ally dismissive remark, oblivious to its effect. She believed then she couldn't draw, yet the desire had stayed with her all these years.

I didn't want my student to give up. I could see so much charm in the drawings she'd made and how sad she was at the thought she might not be able to draw well. Right then we decided we would *never* judge our work as if we were in school. There would be *no* critiques. We would *never* say negative things but simply look for what was interesting and strong, for what was good. In Japanese acupuncture theory, there's a notion that building strengths overcomes all weaknesses and that, when weaknesses are overcome in this way, the results are long-lasting. That was what we'd do.

I remembered too a precept from Yoga: *Change all negative thoughts to positive ones*. We would try this. We're so habituated through our schooling to look for what's wrong. Our approach would be to *look for the good.* It was an experiment.

When we began again, I thought we might feel more empowered to start where we had as very young children—scribbling and simply making marks. How could we feel judged when we were just making marks? But even this made some of us uncomfortable. How do we know if we're getting it "right"? So, we learned another great lesson—what we're doing is not about getting it "right" but about drawing to discover and grow our own strengths. We can practice the art of exploration and discovery even when drawing what we see. It's not always easy to let go of our need to look good or get things "right" but we can do as musician Leonard Cohen so beautifully put it, "Forget your perfect offering. There's a crack in everything; that's how the light gets in." We want to discover our genius and how we can use it.

When our friend spoke up that day, it changed everything. It was such a brave and honest thing to do. And art is nothing if it isn't truth. If she'd not spoken up, we'd simply be an art class studying drawing in the usual ways, trying to hone skills. Practicing. We do that too, of course. But more importantly, we've found a way to step out of our comfort zones into being simply who we are in this moment. Everything great comes from that and from our *desire* to make something of what we have. Desire matters so much more than talent. In it is our deep caring for life and, without it, we don't do much. It hones our focus and helps us be disciplined. It helps us to work with what we have, including our limitations, to find great ideas for our own work. Our club fuels our desire and helps us turn it into the art only we can make.

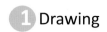 Drawing

*"I always said, 'The teaching of drawing is the teaching of looking.'
A lot of people don't look very hard."*

—David Hockney

· · · · ·

For a while, when I was a student in college, I had little chance to draw as I was too busy with my other work. But one night, my young art history professor held a party and, in the very early hours of the morning, someone unfurled a roll of white paper on the floor and scattered markers around. There were only a few of us left and we got down on the floor and started drawing. I still remember the visceral thrill of drawing again after this spell away from it. It's curious how excited we all were by something so simple as drawing and we carried on until the long roll of paper was filled with scribbles and images, all overlapping. The longer we drew, the freer and bolder we each became. Some of us knew that night, me and my teacher too, I think, that we needed to carry on drawing, that we couldn't be separated from it again and be who we are. In a few short years, my teacher left being an art historian to become an artist. I set out on that path too.

To me, drawing feels like something primal, an inherent impulse to explore and express ourselves visually, to think and be without words. It invites us to forget ourselves and open up to seeing what is. It helps us imagine and envision in ways words can't. Inside all of us who draw and make art is this feeling that drawing takes us somewhere, to a place of truth and perception, and that it is our way to manifest something. We all draw at the start of our lives; some of us leave off at times but we can come back.

Many of us give up drawing when we're just kids. If we had more instruction or support, many more of us might never give it up. Some of us find other ways of being, of course; there are many great ways to live. But some of us need art, and we can begin again. Those of us who have kept drawing will have more developed skills but there's always more to explore. For all of us, if we have desire, we can do something with it. We all have limitations and even with them we can all find our genius—the place we meet and act without hesitation on the inspiration that comes to us.

—opaque watercolor brush drawing

Drawing lets us do many things—jot down visual ideas and explore them further, doodle, describe the world around us, puzzle things out, design and illustrate, make animated films, and make sketches for other kinds of art-making. It can be a simple meditation too. And, of course, it can be an art in itself.

We can use all kinds of tools to make marks—a stick in sand, a twig dripping with black paint on paper, chalk on a sidewalk. Our drawings change with the kinds of materials we use and as our skills grow. But whatever ways we draw, from life or imagination, we'll see the nature of our particular hand and vision.

As we begin working together, whatever our experience, we can simply *embrace* where we are. Just love it. Sometimes we think we ought to be able to draw like Leonardo without having first put in years of practice, as he did. But we can know that even our most fledgling drawings can be full of charm and will point the way forward if we can appreciate what's there. Our first task is to let go of our tight grip on the need to get things "right" straight away. In fact, it will help us to let go of *judgment* altogether and replace it with *discernment*. Our skills and vision will evolve even as we make mistakes.

Let's take note at this point that we can't completely control drawing. If we doubt this, we can look at some of Matisse's drawings and see the errant lines he sometimes left in them. He was a great master yet still made "mistakes". He just kept going and knew that what was strong would overcome any awkward or misplaced lines. Let's just enjoy our mistakes rather than fret and fuss. They're showing us the way forward.

In our club, we'll explore drawing in abstract ways, draw from the world around us and from imagination too. We can draw with our eyes open and with our eyes closed, right-side up and upside-down. We'll draw with all sorts of different materials—pencils, charcoal, crayons, markers, brushes and paint, even scissors. Making such varied explorations will show us the different things we can do with drawing, tell us something about who we are, and make our hand strong.

While there are no shortcuts, there are a few tips. First, of course, we need to *practice*. The more we do, the more able we become. Try to draw every day. Even a few minutes of daily drawing will makes a difference; more is even better.

Next, we'll need to learn to *focus*. Mostly drawing takes us quite naturally out of our linear verbal minds and into a state of *presence,* being fully here in the moment at one with what we are doing. We want to begin to notice where we are when we draw and

Mo Cook—charcoal drawing

if we are *fully* present. It shows when our attention wanders in our drawing. There will be sloppy, inattentive marks. That's when our drawings look like a mess. We can only make great drawings, and art, when we're *fully* present. When our attention wanders, we can gently return it to our hand making marks on the paper. Our ability to focus will grow with practice. When I was in my early twenties, I found it quite hard at first to sit still to draw for long periods of time. Now I sometimes find it hard to leave off; I get so immersed in what I'm doing. We'll talk more about how to develop focus later when we discuss our one rule.

Another tip: we'll want to keep the *big picture* in mind, then attend to details. If we give too much attention to detail, we'll lose our way. We need to remember to step back and see the *whole*.

In our club, we *experiment* rather than trying to arrive at a polished place. We try things out to see what happens. Who cares if it's a complete flop? We can discover *why*. Trying different things out gives us ideas. Not to mention it can make us bold, intrepid explorers. Drawing is great training in creative thinking, and in courage too.

It's good to remember too that drawing is a *language,* a nonverbal form of communication. It's not just the subject of our drawing that matters but the way our vision, ideas and spirit shine through. When we make observational drawings, we may make awkward drawings at first because we can be so focused on what we're seeing that we stiffen up. With practice, we can incorporate memory and an inner knowing and our hand will become more aligned with our vision. Radical acceptance and unconditional love for ourselves just where we are catapults us into our beautiful potential.

Even when we make observational drawings (drawing what we see), we're working partly from *memory* and what we already know. We need to look at our drawing as well as at what we're drawing. We need to learn to *trust* that form will come through us without too much effort. The more we do, the easier it gets and the more free we can be. Drawing what we see is one thing; making something of it, one way or another, is art.

Take note though: we don't need to *try* too hard but just *relax*. Being at ease frees both our hand and our mind. After we make a drawing, we can *look and see* what's there. Looking and seeing is key to awareness. Ask yourself, *what do I love about this drawing?* But we can also consider what doesn't work. It's just fine. It's how we grow.

When we draw from our imaginations, we use our instincts to develop a style or way of drawing that is particular to us. Most of us start this way as kids. Some of us,

especially illustrators, cartoonists and animation filmmakers, continue. Picasso often drew this way. We may need to check references to learn to draw certain things with greater accuracy, but our imagination creates the imagery.

When we draw in abstract ways there's no representation. This kind of drawing can become art when some kind of *order* begins to assert itself. We'll need to learn to *let go* and to engage in a back and forth with inspiration, insight and mark making. Drawing in an abstract way can be a meditation and is a great way to begin a session because it brings us into *focus* and centers us in the moment. We can let our daily concerns go.

There are some who believe that we need to first learn to draw like Picasso before we can make art or dare to be ourselves. We cannot draw like Picasso nor would we want to. He was Picasso; we are who we are. He was of his time; we are of ours and art is a present day conversation. When I was talking with an artist friend recently, he said art is a way to pull down the towers of convention. I love that. We artists try to make art that is *ours* and to lift us all up *now*. If we let ourselves grow from the *inside out,* we'll find our way in each moment. We're on a journey of discovery that doesn't end. That's the fun of it.

Finally, as we work, we'll need to watch our *thoughts* to catch any negativity. Any thoughts that disparage our efforts are unhelpful. When we're new to drawing, we can be especially prone to saying that our work isn't "good" or even that we aren't "good" at art. Let's replace that with: our skills and insights are unfolding. What we think tends to create our reality so let's practice noticing our thoughts and changing them to positive ones. Let's practice radical acceptance! It will take us places.

No matter where we are as artists, we want to cultivate the idea of every moment being a *fresh* start. We want to dive in with the unruly enthusiasm of a kid. When we're kids we're excited to draw because we don't know what will happen and we want to see. It's like something amazing is coming to meet us, and it is! It's like we're dancing with something bigger than ourselves, and we are! Kids' minds are open to wild discovery and ours can be too. Our drawings and art can come alive that way. And we can too.

2 How a Club Helps

*"Find a group of people who challenge and inspire you,
spend a lot of time with them, and it will change your life."*
—Amy Poehler

.

Why work together in a club? Why not just go to art school, learn what we can and carry on? Or why not just take the odd class, hone skills and do our own thing? Why not find a personal mentor to work with us one on one then follow our own path? All of those things are good paths yet a club offers something else—a chance to explore freely outside of our personal art-making and do so alongside others. Exploring outside of our own domain is not something we always do as artists. Doing it in the company of others helps us see the nature of our own skills, talents and visual thinking. We can also get ideas from our fellow artists, and support too. It can build energy for our art, and our life.

Drawing classes have an agenda, certain things we're meant to learn in a pro-scribed amount of time; a drawing club is different. It's a place for ongoing, open-ended *experimentation*. In an experiment, we set up certain parameters but we don't know the end result. We learn to *enjoy* uncertainty and stay *open* to discovery. It takes us into new territory and gives us awareness as well as the skills and courage to explore more.

When our club began, I wondered how we might all work together. We had such different levels of experience. And, for a while, we had a wonderful member who not only hadn't drawn since childhood but scarcely knew who Picasso was either. But we discov-ered something interesting. The one who knew the least about art was the bravest! She jumped into our explorations with an amazing sense of freedom and took great joy in her work. And she came to draw quite well because she didn't indulge in constant evaluation but accepted things just as they are. She was a great teacher.

A club can work really well with people with different interests in art and a range of skills. We can have beginners working alongside people with higher degrees in art. Each informs the other in ways we can't predict. With luck, when we meet, we're all beginners, all fresh to the day's task. We can see all kinds of things of interest in each person's way of

working if we keep our eyes open. Curiously, it can be even more difficult to find our way forward when we have a lot of training. When we have a practiced hand, It's sometimes hard to be fully present in each mark we make or in entertaining new ideas. Working together, we can be inspired by each other and see more clearly where we are.

In a club, we not only make mistakes but we make them in *public*, which gives us a fantastic chance to simply embrace ourselves as we are right now. We all make mistakes. There are times when I make a demonstration and it all goes wrong, and I'm the teacher! I think everyone loves that I made mistakes too. It's great to know that we all have "off" days and all have "brilliant" days too. Mistakes are okay, in life, and in art. They are our great teachers and we don't learn much without them. The only real mistake is trying not to make them.

We might feel disappointed on occasion. Maybe often, at first. I've felt perplexed at times when I can't find a good groove. But disappointment is just a feeling, and feelings come and go like passing clouds so long as we don't cling to them. They're messengers of truths, not ways of being. If we're disappointed one day, we can try to undertsand *why* then just carry on. *Everything changes*. And, because we're working together, we can *reassure* each other.

Working together grows our courage. We can be clumsy, inept, naive and all in *public*. That really grows strength. We can be timid, sometimes foolish, and in *public*. We can learn that it's all okay. We're unfolding our own skills and vision. This kind of public practice strips away old habits of embarrassment and makes us brave.

Of course, working together we see that no two hands are alike. We have different ways of seeing, thinking and making. We can feel free to take ideas or ways of working from other artists. Everything we do comes from the art all around us and from centuries of work that came before us. Our job is to make it *ours*. There is a process of discovery and growth. As we learn to forget ourselves, our own nature, intelligence and experience will shine through. Also, others might see things in our work we might not notice on our own. We can take what feels right and build on our insights.

The purpose of our club is to accept and encourage each other. We know what a gift that is because we can see it in our drawings and feel it in ourselves.

3 Improbable Dreams

"Our ambition should be to rule ourselves, the true kingdom for each one of us;
and true progress is to know more, and be more, and to do more."

—Oscar Wilde

.

When I was starting out as an illustrator, I dreamed of being in certain publications. I'd see the work of great illustrators and dream of doing something as fine, in my own way. Of course, I had to go from dreaming to *doing* before anything could happen. I worked hard at my drawings and, before long, doors began to open even though I was still a very fledgling artist. *First,* comes the dream! We don't need to trim its sails but just set it where the wind can catch it and do what we can to steer it where we want to go.

Our best dreams are the ones that simply come to us. They might well seem *improbable*. We might well doubt them. But they hold our desire to be who we are, each in our way, and to make something of it. Confucius said, "The will to win, the desire to succeed, the urge to reach your full potential—these are the keys that will unlock the door to personal excellence."

First the dream, then we take *action*! Small steps are great; they get us moving. If we think small or play it safe, that's all we get. We'll have to watch for those doubts that creep in and try to clip our sails. Our practice is to just let them go and carry on.

Occasionally, we get dreams that reach beyond the improbable. Like we might visit the Eiffel Tower and imagine we can build it in Toledo! And twice the size of the one in Paris! It's great but we don't know how to build anything and have no real idea why we're thinking this way. If our dreams are too wonky, we won't take action. We'll need to use our critical thinking skills to discern what is true to us. What is our experience, our talent? What are our skills, our insights? Our best dreams come from the truth of who we are.

Improbable dreams are about the alchemy of what we make with our life and what the world we live in wants of us. Our task is simply to learn to *act immediately on inspiration*. This simple idea will lead us forward.

—painted paper abstract collage

4 Attitude Matters

"Put your heart, mind and soul into even your smallest acts.
That is the secret of success."

—Swami Sivananda

• • • • •

We want to cultivate a good *attitude* as we enter the unknown territory of drawing and making art. Things don't always go as we wish but we can still carry on. We'll all get frustrated at times, and we can take note and just let it go. We'll all get tired, and we can take a deep breath, relax and begin again when we feel ready. If we turn away too soon, we won't give ourselves the gift of seeing what might be.

It's important to give ourselves a pat on the back when things get tough. It'll put the sly shadow of self-doubt on alert. There's nothing wrong with doubt. If we're going somewhere new, we'll have it. But we don't want to lather it up or hide behind the curtain of safety either. I love the story of British artist David Hockney, who came from a provincial town in Yorkshire and was made fun of when he first arrived at art school. He noticed, though, that his drawing skills exceeded those of the students who mocked him. He simply carried on, then, soon after graduating, made a series of etchings based on his life as a gay man, coming out in art in a way we hadn't seen before, with absolute confidence and a sense of fun. His great attitude was to just be himself. If he hadn't honored himself, he couldn't have gone on to be the artist he is.

We can also look for any signs of tightness or gripping when it comes to our thinking. We don't need to cling to our ideas about what art is or ways of doing things. We can slip into "un-knowing" and just see what we discover. Curiosity is our friend.

We might want to watch for any sense of strain or excessive effort when we work. When we try too hard, it shows in our drawing. A good attitude might be to let go and just start over when a drawing goes wrong. We can rip it up and toss it into the air. We can let go of an idea or a way of working that we've exhausted. We can begin again.

Neither do we want to settle for the safe bet, the one we know pleases because we've done it before and had a good response. Art is a way of exploring life and gives us a chance to take chances, to swerve off course and bump into the sublime. Let's step off the

beaten path which leaves us at the same old place. Let's come alive and make this journey a vital one. There's no map; we're making our own path.

We can have fun with this trip, mistakes and all. Messy confusions are fine. Sometimes it takes a long time for the fog to roll away, but fog is not who we are. We can be the light that burns it away. We can just keep driving with our eyes open and our headlights on to see what we see. Uncertainties, embarrassments, bumps in the road, dead ends, skids, flops—all can be fantastic parts of the journey, uncomfortable as they can sometimes be. Drive on! That's the attitude that takes us over the mountain.

We'll work in many ways, and some won't be of particular interest to some of us. No matter. We can let go of our preferences. Our club is to *explore* like Livingston and Stanley searching for the source of the Nile—we have no real idea of what we'll find, but we can give it all a chance.

When we work together with our fellow artists, we get added inspiration. Just glancing around the room, we'll see other approaches. We may make comparisons, but let's keep our humor. Laughter is a great attitude.

Let's remember again that Picasso said that great artists steal. We can do what we feel like. Go for it. Try things out and without hesitation; see what happens. We want to keep flexible and even make deliberate decisions to do things that are out of our habitual ways of working. How about using ugly colors? Or making dark, smudgy lines? Or making the same drawing 50 times to see what happens?

An open, even mind gives chance a chance. Let's see what we can do.

Karen Trittipo—found acorn cap and felted wool

5 It Starts With People

"If you love friends, you will serve your friends. If you love community, you will serve your community. And if you love only yourself, you will serve only yourself. And you will have only yourself."

—Stephen Colbert

· · · · ·

Creating a drawing club doesn't mean we cease to continue our personal art practice. We can only do our deepest work on our own; it requires that kind of individual attention, vision and sense of purpose. But we get so many insights when we work together. And we get to support our fellow artists too.

So, how do we begin? A good way is for a leader to form a club by finding a space, inviting others in and planning the sessions. It's great if the leader is a person with enough experience to create compelling explorations and encourage others, and has the interest to do so.

A group of people with an interest in drawing and art can also form a club collectively. We will still need leadership, though, to keep the focus on art and things running on time. This kind of club can work in various ways. A group might appoint a member to run a meeting, have a member run an eight-week session or hire a more experienced teacher to lead the group.

A drawing club can be as small as two people, and on up. The size of the space we have to work in may determine how many people we want to have in a club. Too small a club and we don't build enough energy or viewpoints; too large and we don't get to share in a deep way. A good working number is between 5 and 10. When we go over 12, it becomes harder to manage as it takes time to hear each person's perspective.

Who shall we invite in? In The Saturday Morning Drawing Club, we have left it completely open. Anyone can come. Ours is an *inclusive* club. Beginners are as welcome as more experienced artists. It turns out that it has not mattered in the least whether a new person has little experience. We all dive in, support and accept each other where we are. It's worth noting again that a beginner can often have a fresh approach that gives us all

ideas. And more experienced artists can offer insights to beginners they might not have on their own. The mix can catapult us all forward.

Having a random, self-selecting group of people who all share the desire to draw and explore art works like a charm. Having a club that excludes anyone is counter to the radical, unconditional support for *all* that our club is based on.

I am also a writer and some years ago took a writing class. When the teacher moved away, the members of the class decided to continue to meet. We hardly knew each other yet went on to meet weekly for several more years. About half went on to publish books; the others went happily on to other things having completed that exploration. Had we planned too much, it would never have worked so well. The one real requirement is sharing a solid and happy desire to explore.

We can simply invite people in and begin. Keeping membership open helps us shed exclusiveness and embrace compassion. This is a profound gift of working together in a club: *what we offer others is what we learn to offer ourselves in greater measure.* Most of us have been judged and graded all the way through our schooling, and we can bring that sense of constant evaluation to everything we do. There's an important place for discernment in making art, but it works best when we first learn to leap from the springboard of compassionate acceptance of where and who we are. It's our shared purpose in our club to explore art making, make art that comes from brave adventure and support each other in being the artists we are. This way, we can all shine brighter and brighter.

—pencil drawing

6 Space, Time and Materials

"What we need is to use what we have."

—Susan Sontag

• • • • •

Now to the basics—space, time and materials.

In terms of space, we'll need a room big enough to accommodate our group and one that is affordable, or free, and easy to get to. It can be anything from a large rented studio to someone's kitchen. It depends, of course, on what we have access to and what the group is willing to spend, if anything.

The Saturday Morning Drawing Club meets in a teaching studio at an art center. The room is medium-sized, big enough to accommodate no more than 12 people. We have a couple of large tables in the center of the room on which we all work with a couple of smaller tables to hold supplies and for cutting, gluing or mixing paints. We occasionally have use of an enormous room where we can work on the floor or on large paper taped to the walls. A public facility like this might be willing to host a club and make it part of their education programming. It may be worth inquiring.

If one of the members of a proposed club has a rented studio, that might be another option and the members might chip in toward the host's studio rent. Or we might consider reaching out to artists with studios who would appreciate getting some rent money for the use of their studio for a few hours once a week. We could also consider renting space in schools or places of worship.

Easiest, and certainly cheapest, is to meet in someone's home. This is a great option for a group smaller than six people if there's a good table on which to work. Kitchens are good because they have water and sinks to clean brushes.

As to time, any day or time works that suits the members. Some folks like to meet in the evening after work. Saturdays work well for most people, and mornings are great too as we get down to business before getting carried away with our day. The Saturday Morning Drawing Club meets, obviously, on Saturdays, in the mornings for three hours, from 9 a.m. until noon. But any agreed-upon time is fine.

PEN

CRAYON

PENCIL

CHARCOAL

DRY BRUSH WATERCOLOR

WATERCOLOR WASH

OPAQUE WATERCOLOR

A two-hour session can also offer enough time for a couple of good exercises. Three hours gives a little more time for working, sharing and discussion. Less than two hours wouldn't offer enough time for setting things up and working through a good exercise or two.

When it comes to materials, we can keep it simple. It's helpful to have ebony drawing pencils, twig and regular charcoal, sets of opaque watercolors, brushes, scissors and glue, drawing paper and newsprint, as well as plastic containers for water, dish soap and paper towels for cleaning brushes. We can get other materials as need arises. (There's a list of basic materials in the appendix.)

Our materials needn't be overly pricey or fancy. Brushes, for instance, can be student grade or synthetic. Such brushes also help us let go of any preciousness when we're working as they tend to be less fine. Having coarse brushes that splay a little and surprise us with their effects can help us let go of unnecessary perfectionism, make great mistakes, and get ideas too. The same goes for paper; cheap drawing paper works fine, even for painting on with watercolor. It saves money to buy a ream and share. We might, on occasion, work with higher-quality paper to see how it changes things, especially the richness of color. It can also give us a good challenge to see how our attitude might change when we know the paper costs money! But, in general, we'll stick with inexpensive paper so we can do many versions of our drawing and painting exercises. Recycled newsprint, a very cheap paper, is excellent for charcoal drawing.

We'll need some large scissors for collage work. Glue sticks are fine, or we can get a large jar of acrylic matte medium and use it as a painted-on glue.

In The Saturday Morning Drawing Club we have communal supplies funded by contributions by the members. We each put $20 into a supply kitty most sessions, and I buy the supplies as need arises. We always need paper, and often to refresh our brushes and our watercolor paints too, as well as charcoal and pencils. We keep our supplies at the art center where we meet so no one needs to bring anything, only show up. It can work too that each member purchases their own supplies and brings them to the meetings. In our case, everyone has duplicates at home of the materials we use in our meetings so explorations can be continued during the week if people want.

Finally, and this circles back to the issue of time, it can be good to work in eight-week sessions. The Saturday Morning Drawing Club has three 8-week sessions per

year. The first begins toward the end of September and goes to the end of November. The second starts mid-January and goes until mid-March. The third and final session starts the beginning of April and ends the beginning of June. We take summers off.

Having breaks between sessions offers lots of benefits. First, we don't tire of working together. Also, we're all busy people with work, family and friends. If the sessions went on longer, it would be a good deal harder to keep attendance up and keep the meetings fresh and vital. Energy could flag and we like to keep it high because it makes for more daring explorations. It's good to know that when we don't meet, many of us miss the club and appreciate the energy and insights we create together. I believe our scheduled breaks are one of the reasons we've been able to keep the club going for so long, albeit with some members rotating in and out. When we don't meet, we're each doing our own work and making our own discoveries. It's exciting to share these when we get back together.

From my perspective as teacher, eight weeks is also a good amount of time to explore a theme, if we choose to, such as collage or drawing in paint. I'm not a great planner and never know the whole of the eight-week course in advance because I like to respond to what shows up as we work and organize exercises around what I see as we go. For instance, if we're struggling with portrait drawing then we can spend an extra couple of weeks on it. Even if just one or two people are struggling, all of us benefit. I like to keep it loose in this way, but I am the teacher. If a group is working in a more democratic way, it might well be of benefit to have an eight-week plan and stick with it. We will discuss this in the next chapter.

Although the summer break is long, it can be surprising just how enthused we all are to meet again in September, to share the art we've done and chat about our discoveries, and our lives a little too. We give space for more sharing in the first meeting when we reconvene in September. Working in eight-week sessions saves us from burning out or having the group grow stale. Just as at the dinner table, it's always good to want more than to eat too much and fall asleep.

To get started, we needn't concern ourselves with having the perfect situation and all the supplies on hand. We only need pencil, paper, a table and a few friends to start. Beginning is what matters because once things are in motion, more things emerge. Dive in, then carry on.

7 Running the Club

"I suppose leadership at one time meant muscles;
but today it means getting along with people."
—Mahatma Gandhi

• • • • •

To run a club, we'll need a leader. It may well be the person who feels inspired to start the club. If a few folks decide together to start a club, then they can decide whether to appoint someone as leader, rotate leadership or hire an outside artist.

A leader is someone who can motivate, inspire and organize. It helps if the leader has art skills. If we're rotating leadership, we can lead the group with exercises we feel excited about or are interested in, if our skills are modest. A good, positive attitude, a love for art and ideas are all we need to be a leader. Some knowledge of contemporary art helps, as this is where we'll get much of the inspiration for the explorations we'll make. The Internet is full of art where we can see the work of our fellow artists and find many new ways to explore. Our goal is to grow our skills and discover ever more vital ways to express ourselves visually.

In The Saturday Morning Drawing Club, I lead the meetings and determine what we'll do each week. Sometimes my ideas come from things I see or am doing in my own art practice; often I try also to respond to what I see in the group. For instance, if I see someone could really benefit from drawing strictly from life, I try to arrange some weeks where we do just that. I never say we need to do this because a beginner is lagging behind. In fact, I never mention why we're doing something; often it's simply something that I'm excited about trying with the group. But I know we can all benefit from any exploration.

The group too will suggest things they'd like to explore. I try to respond to these requests, but don't always succeed. Because I'm a teacher and artist, I'm following a kind of inner path. When I see people flourish doing one kind of work or another, I want to build on that. I listen but, as the leader of the group, I take charge. Occasionally, someone expresses a preference: "I think we should draw more with charcoal." But I still follow my own instincts of what I think will work for the whole group.

As the teacher, I set up our explorations and also participate in them. I want to keep my own interest alive and to know how the exercises are working. Sometimes, I'm working so hard I forget to look at what the others are doing. Mostly though, I encourage all of us to look around at what our fellow artists are doing so we can get ideas. Occasionally, I go around and offer suggestions. But for the most part, I want to avoid creating the self-consciousness that can come from someone looking over shoulders. Often I'll demonstrate how we can do certain things and offer individual support when people want it. What's easy for some of us might be hard for others, and vice versa.

Leading a club does take some work. We do need to think about what exercises we'll do before a meeting begins and have the appropriate supplies on hand. We may need to troll the Internet for ideas and even print out, as I often do, sheets of paper with examples of other artists' work that might inspire us all. It takes time to do it well.

That said, if we're starting a club, we may want to ask that members pay a fee for each session. The art center that hosts The Saturday Morning Drawing Club pays for my work as a teacher. The fee the members pay is a reasonable one.

Charging a fee guarantees two things. First, that the leader will provide a great experience for the members. It holds the leader accountable. Second, it assures the group that there will be a good plan in place for each week. Because we are an inclusive club and welcome all, it's best to set an affordable fee. Just enough so the leader is compensated reasonably for time spent and so the door can be open to many people. Of course, if someone simply can't pay, we can make appropriate allowances. There are always opportunities for generosity. If a group is running the club collectively, a fee may not be appropriate as each member shares responsibility.

Once leadership is established, it helps to have an idea of what we'll focus on for eight weeks. Later in this book are three 8-week session plans that provide a jumping-off place. Each of these can be expanded and altered as we go forward.

In our club, we often begin our morning with abstract drawing to loosen up and bring us into focus first. We then often do simple skill-building exercises like making observational drawings in various ways. Some of what we do is experimental, and this is often the most fun. For instance, we might work with odd materials like drawing with sticks and paint. Sometimes we'll do group drawings, all working on the same piece; sometimes we'll draw with our eyes closed. We might also work with sketchbooks for a whole session.

This way we can continue our explorations in our sketchbooks during the week as well, bringing them in to share with the group when we next meet.

In planning what we do, we can go week by week or think in terms of chunks of time. For instance, we might draw on a large scale in charcoal for four weeks, then draw on a smaller scale with opaque watercolors and brush for four weeks, all the time making observational drawings. Or we might spend eight weeks exploring abstraction, starting with making marks with charcoal, then paint and crayons, and looking at the work of various abstract artists each week for inspiration, thinking about what they do and why. Or we might get inspiration from David Hockney and make colored pencil drawings. These might be outside our individual art practices, but they will all build skills and give us ideas.

If we're running the club collaboratively, we can have a short discussion on how to proceed. We don't want to give up hours to waffling discussion though, but get down to work. We'll each have to let go of our preferences sometimes. Almost any exercise will give us lots to discover if we bring ourselves into it.

We might use the lesson plans included in this book to begin then, later, make up our own. We can each write suggestions and have an e-mail exchange, for instance. I sometimes invite our club to jot down ideas at the first meeting of a session. If there's a strong desire for something, it's nice to be able to include it. Or we could pull ideas out of a hat and work on them randomly. The point is always to get working.

However we proceed, we're looking for our own engagement with an exercise. What we do matters less than how we bring ourselves into it. We can all engage with any exercise and also tweak it in any direction we want to as we go. Why not? As artists, we make up our own rules. Or, as musician Neil Young said when someone started shouting out requests at a concert, "Be quiet! I work for myself." We work for ourselves.

We can also remain sensitive to member preferences. Once a member of The Saturday Morning Drawing Club expressed a preference for pencil drawing when we'd been doing a lot of brush drawing. Drawing with a large brush can curb over-fastidiousness. It saves us from getting knotted up, but we need to shake things up in our club—not focus just on one thing. In our case, we returned to careful pencil drawing, which gave us a stab at a more subtle expression. *Everything* is worth exploring. This is our *practice*.

So, first a leader then a plan for each meeting. That way our focus can be solely on our art making.

8 Working Together

"Coming together is a beginning; keeping together is progress; working together is success."

—Henry Ford

· · · · ·

In any group, there are dynamics. We'll each of us sometimes be tentative, or uncertain, or perhaps insensitive. Or just fine. We might be very chatty one morning and completely inarticulate after a late night out the next. Some of us might be shy sometimes, especially when new. However we are on any particular morning is not likely to be the whole of who we are. We're all dealing with the great kahuna of life, all having our ups and downs, great adventures, tender moments, challenges. And even as we try to stay centered, we all slip away from a sense of calm at times. We sometimes become irritated with what we're doing or impatient, even bored at times when we lose our focus. It's okay.

And even though we're meeting to draw and explore art-making, we may find ourselves chatting about this and that. We all need to remember that we're there to draw and it's not just for the purpose of learning skills or growing our art. This time we spend with our focus on drawing is a meditation too. It can bring us back to the heart of who we are, if we let it. So, if possible, it's best to have a short sharing time to begin then bring our focus, as much as we can, fully to art.

When we're discussing art, we who share a lot will need to consciously give space for quieter people. More introverted people should feel comfortable chirping in. Our club is a place for open-minded discussion of whatever comes up during our explorations and on the subject of art. All contributions are welcome and no expertise is necessary. Some of the best questions come from beginners.

We may each be disappointed in our drawing at times. That too is okay. We can remember that we're on a path of learning and growing. We do not need to look "good" or be the "best" to matter. We can let go of judgment, of ourselves and others. We can just be who we are and where we are. That is what art is made of. We're not in our club to make masterpieces but to be who we are. That's a masterpiece.

Mexican author Don Miguel Ruiz wrote a book some years ago called *The Four Agreements*, in which he outlines four principles derived from ancient Toltec wisdom. Following these principles is said to help us create love and happiness in our lives. They're excellent principles for *The Drawing Club of Improbable Dreams* as well and for what we tell ourselves as artists too.

Here they are:

1. Be impeccable with your word. Say what you mean and take care not to indulge in gossip or other harmful chatter. We can try to direct our words toward love and caring. In our club, this is congruent with looking for the good in what we do.

2. Don't take anything personally. What others say and do is simply a projection of their reality and has nothing to do with us. Occasionally a careless word might slip out. We are human. But we can let it go. It's not about us, but them.

3. Don't make assumptions. We can ask others what they really mean rather than jump to our own conclusions. Or we can just let it go. Asking for clarification opens up discussion of ideas and possibilities.

4. Always do your best. This can change under different circumstances. Some days we'll be more present than others and have more to give. If we're doing our best there will be no need for self-criticism. It's more fun and more rewarding to give it our all.

Keeping these principles in mind is a great way to work with others as well as make art. It's freeing and kind.

Working together, we can discover many things that we might not when working on our own. There are many kinds of art and we each have particular interests, skills and experiences. It's so interesting to see how we each work and it can give us lots of great ideas for for our own art. Taking chances together in a supportive environment builds our courage, especially when we embrace the notion that mistakes are worth making.

With our focus on art, working together is empowering, illuminating and fun. We might remember here the teaching of the great Swami Satchidananda who said that life is meant to be fun. Art can be too.

A Tip

*"There is a time for silence. A time to let go and allow people
to hurl themselves into their own destiny."*

—Octavia Butler

• • • • •

In the club, we work in silence or listen to music. What we don't do, as already mentioned, is chit chat. This is an important tip. If we chat, we lose focus and we'll lose the chance to go where the work might take us.

Mostly, talking vanishes quite naturally as we begin working but a club is a social entity too. It's helpful to have a time of sharing at the beginning and to keep the focus on art. Mostly, in The Saturday Morning Drawing Club, we share art we've made during the week and talk about it. Sometimes we just tell a little of what we've been up to in our lives. It's important though to avoid deep discussions of personal problems though we'll all likely touch on the events of our lives. If we're feeling overwhelmed about a particular concern, as we all do from time to time, it's good to get the appropriate support. What drawing will offer us is a beautiful time of meditation, a way of being fully in this moment and letting everything else go. We have a time of sharing and then we turn our focus to art. It's a beautiful place of letting go.

Occasionally in The Saturday Morning Drawing Club, even with all our years of working together, I have to remind us all to let the talk go and focus on the work. We all get overexcited at times, me too. Once we dive in, it's easy.

Total silence isn't necessary; music can be a way to get into a more meditative state. Soft music works better than raucous. Sometimes silence is too jarring, and we can encounter another artist's creative energy and feelings in music. This can open the door not only to focus but also to our deeper feelings, the ones we want to get to in our art.

Again, we are here to explore drawing and art. That is our focus.

⑩ Our One Rule

*"People deal too much with the negative, with what is wrong.
Why not try and see positive things, to just touch those things and make them bloom?"*
—Thich Nhat Hanh

· · · · ·

Now to our one rule! We will only look for the good in our work. Instead of looking for what's wrong, we'll look for what's strong; for what's beautiful and unique. We can build on our strengths if we know what they are. And, as mentioned earlier, if we build on our strengths, they'll overcome whatever is weak.

Our one rule is based in ancient Yoga theory, and drawing can be a yogic practice too. The goal of Yoga is to unite us with our true selves, that part of ourselves that is steady, wise and loving. In Yoga, we do physical postures to benefit health. But we use these postures also to develop our minds and spirits. How does this work? The postures are quite challenging. Even when we have a lot of experience with them, we will go to the edge of our abilities. Not over the edge; we're certainly not trying to prove anything. In fact, Yoga teaches us to simply see where we are in this moment. When we feel pain or strain, we'll notice, of course. Yoga asks us to pay attention to the thoughts that go through our minds. "This hurts!" or "This is too hard!" Or "I can't do this! This is ridiculous!" Or "That's it! I've had it with Yoga!" It's really interesting the things we tell ourselves. And all we're doing is a stretch that involves a little discomfort!

Drawing gives us the very same training. We are drawing, and we can notice both what shows up on the paper and in our thoughts. Maybe our drawing doesn't look like we'd like it too. Our minds will likely begin churning. "This is horrid! I can't draw! Everyone else is so much better than I am." Even, "I'm a complete failure!" We can tell ourselves some amazing nonsense! And we all do at times.

So, Yoga teaches us to notice our thoughts. It suggests that the thoughts we have about how we feel discomfort in a physical posture or missing the mark in our drawing are the attitudes we might be bringing to many other things in our lives. What do we do when something is a challenge? Do we tend to give up? Or do we persevere? Do we get knotted

up, fretful, irritated? Or can we maintain a sense of peace and open-mindedness? Can we simply be curious? Our thoughts are powerful creators of our reality. If we tell ourselves we can't do something, we likely won't do it. If we tell ourselves we're no good at something, we won't feel empowered to work at it. What we focus on tends to grow. Our first work is to notice our thoughts.

In our club, as noted, we draw in silence or with music. One reason is so that we can be fully in the nonverbal space that drawing takes us into and it will be easier to notice our thoughts. Drawing can serve us in exactly the same way the physical postures of Yoga do. Like the postures, it teaches us to focus fully on what we're doing and be completely present to this moment in time. The American yogi, Ram Dass, titled his book on Yoga, *Be Here Now*. It's a good philosophy for life because it means we're not obsessing or becoming sorrowful about events in our past; neither are we fretting and becoming anxious about our futures. We're just here and, actually, in this moment, we're breathing and alive and full of beautiful potential. Even if our bodies hurt, even if drawings are wobbly. So, we want to just embrace that beautiful potential and the fact that we're here.

When we draw, we learn what Yoga calls one-pointed focus. This is what Yoga postures also teach. They are difficult enough that we can't think of our shopping list at the same time as we're doing them. If we don't focus, we might fall over. Drawing too teaches us this one-pointed focus, if we allow it to. We'll need to make a conscious decision to let everything go and just focus on what we're doing. Mostly drawing entices us in quite naturally, and without effort, because it takes us quite naturally out of our verbal minds and into our imaginative, spatial minds. But drawing, especially drawing what we see, is difficult. It's hard to get it "right" and so we need to bring our full attention to it. Just attention, not fretful effort! In this way, it's such beautiful practice because it gives us the opportunity to come into a place of peace where we can forget the events, good and bad, large and small, of our everyday lives. We can forget our complaints and disappointments and fears. We can come into a state of present moment awareness. Some of us resist stillness because we're so afraid there's nothing there, that we might be lonely or that we're somehow outside of it all. But, in stillness, we discover everything's there—incredible peace, inspiration, love. And it's all inside of us. We are an inextricable part of the whole universe of Life. For all of us, this is the heart of who we are and we can only really connect with this when we come into the moment in stillness.

So, when we draw, we come into the present moment; thoughts are coming and we can learn to notice them. Just notice. We don't have to battle them or push them away, just notice. They're old friends, often old habits. Some are not all that helpful now but they likely emerged for good reasons and, at one time, reflected where we were in our understanding of life. We can just notice now and let them gently slide by. Thoughts come; thoughts go. Feelings come; feelings go. It's just the way it is. Yoga teaches us to be gentle. We don't need to force thoughts to go away or get our machetes out.

Yoga then takes it a step farther. As we really see what our thoughts are, we can begin to replace them with positive thoughts. "This is hard!" might become "I love how I drew this one line!" "I will never get this!" might become "Every time I do this, I learn something!" Or "Everyone else is doing better than I am!" might become "I'm excited to see where I might go as I carry on!"

So, we begin to notice our thoughts and replace every negative thought with a positive one. This becomes what Yoga would call a mental discipline. We'll need to stay conscious of it and attend to it. We'll likely notice that old, unhelpful habits of thought will work in wily ways to reassert themselves and convince us that they're entirely logical. They can be very, very sneaky. The litmus test is how do the thoughts make us feel? If we have thoughts that are making us feel diminished or sad or confused, we can be sure they are not helpful no matter how "logical" or "right" they seem. We'll have to practice this discipline of watching our thoughts, noticing, letting negative thoughts go and replacing them with positive ones. The more we practice, the easier it gets. Yoga is a system of thought more than 5,000 years old. It has lasted for a reason!

A note about feelings as they can come up a lot when we draw and make art: feelings can let us know where we are in this moment of time but they aren't the whole truth. We can notice them too, see what they're telling us, and let them be free to dissipate. Feelings can be like a fog. Stand still and the fog will drift away or evaporate in time. If we try to run away, we may not be conscious of where we're headed. It can be helpful to sit still in the moments of doubt and uncertainty that come to us all in the art making process. Just sit and see. All of our experiences and feelings help us learn. Yoga gives us ways to be still and peaceful in the midst of all sorts of life events. It's a great discipline for artists.

After learning to watch our thoughts and change them to the positive, Yoga's

ultimate insight is to then ask us who is observing our thoughts? It's a great question and why I love Yoga so much. It's a kind of science. What lies beyond our thinking mind is what Yoga calls the Observer Self, that part of us that is never ruffled and simply observing. It's what some of us might call spirit. The goal of Yoga is to align us more and more with spirit, the loving, compassionate, peaceful part of ourselves. It's at the heart of all of us though we can all become detached from it. Practices like Yoga and meditation can bring us back to the heart of who we are. Drawing can too, if we attend to it in that way. It's in this peaceful, unruffled place that inspiration comes to meet us. When we can act on inspiration, as we'll need to in our drawing, then we'll find our own beautiful way.

So, this is the one rule of our club, and we can bring it into our personal life too. We look for what's strong in ourselves and in our work, and let the rest go. We replace any negative thoughts with positive ones. Everything changes as we go forward—today we are here, tomorrow we move into new territory. But today, let's be here in as good spirits as possible. Let's give ourselves and our friends a pat on the back! A positive feeling helps us leap over doubts and take chances. It helps us feel that we'll discover something of value if we carry on.

If we're always looking for what's wrong or judging our work harshly, we can sink into disappointment and hold ourselves back. Or even give up. Of course, we're all sometimes disappointed when things don't turn out the way we'd wish. But falling short gives us ideas too, and we can think how we can change the outcome next time. Sometimes what we think we want to see isn't as interesting as what actually appears on the paper.

Working together, we get to support each other in this process. There's nothing like the encouragement and insight of friends; it gives us energy and courage too! It helps us feel free to do whatever comes to mind, and without hesitation. Only in this place do we make the art we're meant to make, freely, each in our way.

We want to offer intelligent insights about our work not flaccid flattery, of course. We are truth tellers. We have to look with care to find the good—boldness or sensitivity in our mark making, a sense of design or color or composition, the ability to surprise, honesty in the work, great ideas, unusual thinking, deep feeling, a special naiveté. There are many things. We gain insight, skill and power through building on these strengths. And so we come to know ourselves too.

We do each have weaknesses and limitations, and it's good to know what they are. We have to work with what we have and remember that what we focus on grows. When we focus on our weaknesses, we'll grow them and we may want to give up. When we see what's unique to us and what we do well, we can focus on these and grow them.

When we're beginning, it may be hard to find what's interesting or strong. We'll need patience and to learn how to look. We may need to change the way we think about art; it's always evolving and often more than we think it is. It could be that we're comparing ourselves to an apple when we're more like an orange.

Within everything we do with focus and presence, we'll find something fine. It may be a small thing to begin, perhaps the humor of a wonky smudge or one strong, assured line or a wondrously odd use of color. But it may be huge too—a brilliant idea, a fantastically detailed drawing that makes us see more clearly, a painting that tells a story that words can't. And it may also be that we're willing to try new things, that we put our whole selves into our work, that we allow ourselves to make fantastic, wild mistakes, that we become good critical thinkers, that our passion for art grows, that we see in new ways. Or that we learn to offer radical, unconditional support to ourselves and others; that we grow compassion and kindness. These are not small things. It's not just what emerges on paper that matters but how we work and live life too.

Looking for the good is a shift in attitude for many of us. It requires attention at first. Often others spot things in our work we don't see ourselves which is one great reason for working together. And we offer them the same gift.

The corollary to the rule is this: We speak no negative word. That is how the rule manifests. We don't offer suggestions for how to "improve" someone else's work or say how something is "off" or "wrong." If someone asks, we can offer suggestions but we can remember too that everything is subjective. As artists, each of us has to find our own way forward. That's the journey and the fun of it.

We might even begin to notice that, with this one rule, we are not just changing and growing our art, but our lives too.

11 Making a Plan

"Our goals can only be reached through the vehicle of a plan, in which we must fervently believe, and upon which we must vigorously act. There is no other route to success."

—Picasso

• • • • •

Let's now make a plan. As mentioned, The Saturday Morning Drawing Club is organized around three 8-week sessions in one year. I highly recommend this approach as it gives plenty of time off for members to proceed with their own art making and bring energy back into the next session.

Next, we'll also need to decide how long each meeting will be, either two or three hours.

Then, we'll have to decide on the overall curriculum and whether we'll explore one theme, like drawing people or working with sketchbooks or making collages or working with abstraction, for the whole eight weeks, or jump around a bit. In The Saturday Morning Drawing Club, we've done both. In the early days, we began with making observational drawings in charcoal and stuck with that for a year or more. Later, we came to draw with brush and black paint, then we started drawing in color with brush and paint, making both representational and abstract work. We've studied composition by making painted paper collage, which led us to making cut paper images. This year we began studying other artists and making work based on the inspiration these artists have given us. It's been a great way to internalize what they've done and to stretch our own ways of working. Sometimes we've copied a drawing by a master too, another great way to learn. Later in the book are three 8-week lesson plans to give ideas for a full year of sessions.

If we don't have a defined plan for the eight weeks, we'll need to decide in a more spontaneous way what we'll do in each session. Plans are meant to be flexible, even discarded sometimes. We need an idea, though, for each meeting so we can get right down to work.

In each meeting, we should have time to make a couple of explorations. For instance, we might do portrait drawing and start with charcoal contour drawing then move

on to using shading. Or we might do painted paper collage, studying color in the first hour by painting squares of color, then making images or a collage with them in the last part of the session to see how colors work together. Or we might copy a David Hockney colored pencil drawing in colored pencils to try to undertsand how he did his then try a colored pencil drawing of a still life on our own. We're exploring to see what happens.

Once we have a plan for a meeting, we need to gather the appropriate supplies. In The Saturday Morning Drawing Club, I set out supplies on our work tables before everyone arrives so we can get right down to work. It's helpful but not necessary.

It's essential though to have a plan so we can get right down to work. There's no need to fuss—general agreement is all we need to begin and we can adjust as we go. Keeping our planning open and fluid is fine. It's how we make art.

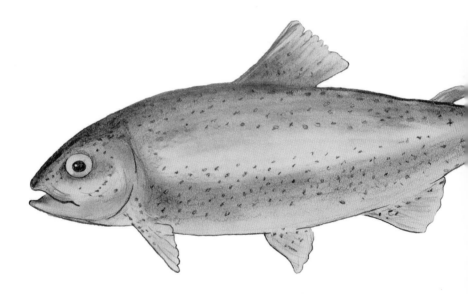

12 Show and Tell

"I force myself to contradict myself in order to avoid conforming to my own taste."
—Marcel Duchamp

• • • • •

After we make an exploration, we tape our work on the walls to look at it or we all walk around the tables together studying each person's work. Taping the work on the walls gives us a chance to see our work placed together and to stand back a bit. It's interesting to see how we each approach the same task and get such different results.

Let's think about how we look at our work. What we look for will depend on the exercise. If we're drawing with our eyes closed, our response will be very different and probably require less time than if we're considering an observational drawing we've made with greater effort. On the whole we're looking for a sense of *truth* and *coherence*. It shows in our drawing when we look too much at what we're drawing and not enough at our paper, and vice versa. It shows when we try too hard, and we can learn to lessen our grip on effort. It shows when we're thinking of other things and we can try to bring ourselves more fully into what we're doing.

We're looking too for the *qualities* each person brings to their drawing. As we make and look at more and more of our drawings, we'll see the nature of each person's hand. That is something to note. Some of us are sensitive in our drawing, some subtle, some bold, some tender, some funny. We want to discover our qualities.

We want also to feel confidence in an artist's intentions and see that the artist is aware of what they're doing. So we can look to see if there is a *consistency* to how we approach a drawing. Are we bringing the same attention and approach to the whole of our drawing? Or do we forget where we are halfway through?

Mostly, our blind observational drawings (drawings in which we look only at the object and not at the paper) are full of life and a great sense of freedom even if they aren't all that accurate. Often, when we focus on getting things accurate, we lose that sense of freedom and assurance. It takes practice to bring assurance and accuracy together with our own sense of self.

In our club, we look first at everyone's drawings together to note general qualities of following through on the intention of the exercise. If our exercise is to draw in an abstract way and we draw flowers, then we can ask ourselves what it is that prevented us from fully exploring the exercise. Does it mean we aren't comfortable getting outside certain parameters or thinking in new ways? We can change that.

We are looking at and seeing what we all do so we can learn. Once we've taken in the whole, we go back and look at each individual's work, one by one. Talking about what we see brings it into awareness. Often we each notice different things so it's important to give this time. In observational drawing, we're looking for how well we've captured a subject, if our approach is consistent, whether our drawing is clear or where it might be muddled, and whether spirit shines through. Too much effort is a spirit dampener.

We can also look and see whether a drawing captivates our interest and makes us want to keep looking, or are we satisfied with a glance? We can explore what makes the difference. Does a simpler drawing have more power? Are there things we can leave out?

Our rule, of course, is to look for the good and never criticize or say negative things. We only need to offer suggestions when asked.

We can ask questions about our own work too. We might ask what will engage our viewer more fully and keep them looking. Sometimes there's something we can exaggerate a little, or something we can prune. Exaggeration is a great tool that often pushes us to see new ideas. Simplifying does the same.

Good questions help us think conceptually about what we're doing. Conceptual is a big word these days, when idea takes precedence over matter and sometimes feeling too. The idea is paramount in Marcel Duchamp's famous piece, *Urinal*, for instance, made in 1917. In our drawing club, we mostly work in more traditional ways but we still need organizing principles or ideas. In every drawing, and every piece of art, we'll want to have an overall approach or organizing principle to give clarity to our art.

The biggest questions are the ones we dare ask ourselves. Who am I? And am I willing to go where I haven't been before?

13 Keeping a Sketchbook

"All artists are willing to suffer for their art.
But why are so few of them prepared to learn to draw?"

—Banksy

• • • • •

In the wondrous world of serendipity, just as I arrived at this chapter, I received an e-mail from one of the members of The Saturday Morning Drawing Club with a scan of a couple of pages of a sketchbook she kept in the early years of our club. It was a blind contour drawing of a flower in black line with many smaller ones in color along one side, quirky variations on a theme. I hadn't forgotten the drawing and was delighted to see it again. Her comment, "I've been looking at early art club notebooks. Freedom. Makes me happy." It made me happy too! It's great to see where we've been. Everything changes with time.

In The Saturday Morning Drawing Club, we once spent a whole eight-week session working with sketchbooks. I asked each person to bring a clean sketchbook to our first meeting. Have you ever bought a sketchbook then found it too pristine to draw in? We got rid of that notion on day one. The first thing we did was take a pencil, close our eyes then flip through the pages making scribbles here and there without looking. Just marks on multiple random pages, maybe twenty or more. We also made a few tears and ripped out a page or two, tossing it onto the floor. We wrote our names on the first page and the year of all this wild action. We ruined our sketchbooks in less than five minutes!

When there was nothing pristine about them, we began to make observational drawings starting on the first page. We worked in all sorts of ways—*contour* (drawing just the outlines); *blind contour* (drawing just the outlines but without looking at your hand); drawing with shading in charcoal and pencil; brush drawing in color with paint; and so on. These drawings made it even messier. Now we had spilled paint, smudges from our fingers, torn pages and, of course, our original scribbles. Soon, we added cut paper collages and wrote notes here and there about things we wanted to think about. We pasted in photographs too of anything that sparked ideas—people in the street, landscape, other

art. When we arrived at a page with one of our original scribbles, we simply drew on top. Nothing was precious. Not the drawing nor the scribbles. We were using our sketchbook to simply practice our drawing and explore. What might happen if …?

We used words too, jotting down ideas. Not all visually expressive people are comfortable with writing, so some of our group didn't go in that direction. But some are and words can help us get clear. We can bounce between words and sketches. A sketchbook is another place to explore.

Right from the beginning, it's handy to have a club sketchbook for further drawing practice and to develop our own thoughts and ideas. We'll see that some explorations are more alive than others and those are the trails we want to follow.

We can also use our sketchbooks to collect images of the work of other artists we like to inspire us. We can scan the Internet to find art we love and print out images to paste in our sketchbooks. This gives us a chance to see what excites us at the moment and ideas for our own work. What interests us may well change over time. And there may also be artists we return to over and over. It all tells us something.

Some of us will also use photography for ideas and references, and we can paste these into our sketchbooks too. Carrying our camera or camera-phone and taking shots on the street of things that interest us can be a good practice. Perhaps we'll see something in nature, spot a great color in a shop window display, or a pattern of stains on the concrete sidewalk. Inspiration is everywhere. We can make notes about these ideas too, if we like. Or we can make a digital record of such finds on Flickr, Pinterest, Instagram, ArtStack or other sites to which we can post images and comments. We can make a kind of Internet scrapbook to record and share our interests. Online, others can comment and add photos too. We can get a lot of energy this way.

In The Saturday Morning Drawing Club, we only occasionally share our sketchbooks with each other. Most of our fledgling or undeveloped ideas we keep to ourselves. We use them as tools for our own art making. Should we ever feel stuck, looking at our sketchbooks will give us a good jolt of energy as well as ideas.

14 About the Sessions

*"I found that things became a lot easier when I no longer expected to win.
You abandon your masterpiece and sink into the real masterpiece."*

—Leonard Cohen

• • • • •

In the next chapters are three 8-week session plans. Our goal in doing the exercises is to explore openly rather than try to make finished pieces of art. We want to experiment, try out new ways of drawing, and make some good mistakes.

The first session is centered on basic ways to practice drawing. All of the exercises can be altered, or added to. The drawing exercises should help us look with care at the world around us, get comfortable with materials, feel able to draw what we want to and give us fluency with our hand as well as ideas for how to make our drawings our own.

In the second session, we'll explore working with different materials and in different ways, painting, making painted paper collages and simple monoprints. The boundaries between drawing and other forms of image making are permeable. If we're making a contour drawing with a brush, is it a drawing or painting? It doesn't matter. But we'll get lots of ideas for great ways to work.

In the third session, we'll focus on growing our adventurous, intrepid selves and honing our individual visions by getting out of our comfort zones and working in somewhat unusual ways. We'll try working on a bigger scale and collaborating too.

Later, we'll see how the exercises can be expanded and altered so we can continue on.

Our purpose is to use drawing to unfold ourselves as artists. We can feel free to go over the edge of our abilities so we see where that edge is. There's no progress without taking chances, and the only real mistake is holding back. Our goal is simply to be ourselves—who and where we are in this moment, fully and without hesitation, and to notice. And then continue to grow.

The exercises are designed so that we don't know how things will turn out until we do them. Our job is simply to dive in then look and see.

Some exercises may seem hard to some of us. We may not yet have the skills or like working in a particular way, but we can grow a willingness to just try things. Some exercises will interest some of us more than others. We can try to let go of some of our preferences perhaps and just work. If we show up, something will show up to meet us.

Some things may feel too easy for some of us, but they're not easy if we fully engage with them. How can we take things further? That's a question we might ask. We can make every exercise a teacher if we *focus* and bring ourselves into it. We can watch for any tendency to evaluate too much and simply choose to engage. Any exercise can give us something of value if we engage with it. That's up to us.

It's helpful to let go of any investment in how things turn out and just allow things to be as they are. Some days will offer greater rewards than others.

The exercises are spelled out in a succinct way. If we don't understand fully, it doesn't matter; we can just begin anyway. There's no absolute right or wrong. We want to self-empower and make things work for us. We can always feel free to alter and rearrange, do in consecutive order or backwards. What matters is that we get down to it and into it.

Materials are noted at the beginning of the exercises. If we don't have certain materials, we can improvise. Again, the appendix has a full materials list.

At the end of each exercise, as discussed, we look at everyone's work together.

So, to repeat, the exercises are designed to:

- build skills
- help us entertain "mistakes"
- give us ways to practice
- teach us focus, detachment and perseverance
- build courage
- give us ideas
- help us know and embrace ourselves as we are

Now, let's get started!

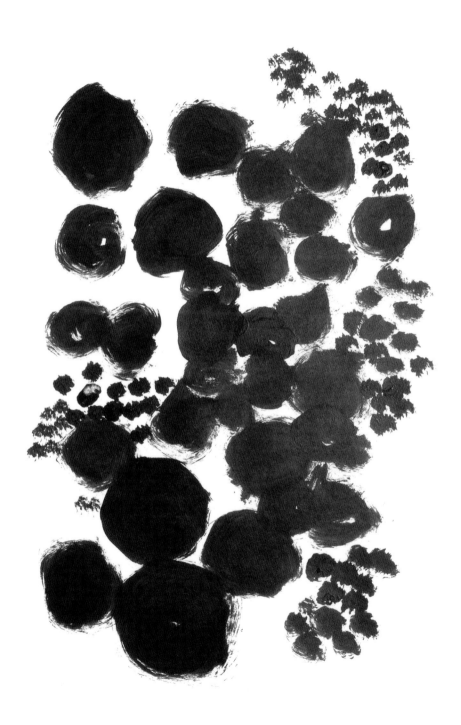

15 Session 1

Basic Drawing Practices

We'll be working with basic drawing exercises in this session to gain skills. Practice matters. We can try expanding on these ideas on our own time too.

Week 1: Abstract Drawing in Black and White

Materials: Dawing paper 14" x 17" or larger. Black acrylic or poster paint. #6 and #12 brushes. (Charcoal. Black crayon or oil pastel.)

TIP: *Always try to bring full attention to the hand and just see what happens. Try to avoid any tendency to insert imagery. For inspiration, check out Chinese calligraphy.*

Put on some music and begin to make marks with the brush and paint. (Over time, try the exercise with all of the mediums listed above.) Make long, wavy lines and short, staccato lines, dots and blobs. Explore. When everyone has done six or more drawings, stop and take a look. Note how everyone's drawings differ.

Try it again, now taking inspiration from each other. We can use different sized brushes and begin to introduce pattern or repetition of marks. There is *no* right or wrong. Adjust the pressure on the brush to make thick and thin lines. Adjust the amount of water on the brush to make washed out greys and deep blacks. Don't overthink, just dive in.

This is a beautiful meditative exercise, one we return to often in The Saturday Morning Drawing Club. It can be used to build fluency in the hand and help us be at ease with making marks. It's also useful in helping us see ways to compose our drawings and how different marks can be expressive. It can serve as a warm-up exercise too.

NB Drawing can be a meditation, a place to simply *be*. Most of us find this to be a very peaceful practice. In this peaceful state we can begin to watch our minds as well and notice the thoughts that appear. We can gently let the ones that aren't helpful go and return our focus to our drawing.

The attitude we bring to our drawing is often the one we bring to the whole of our lives. Drawing gives us a chance to see where we are and choose a good attitude.

Chales Studen—acrylic paint brush drawing

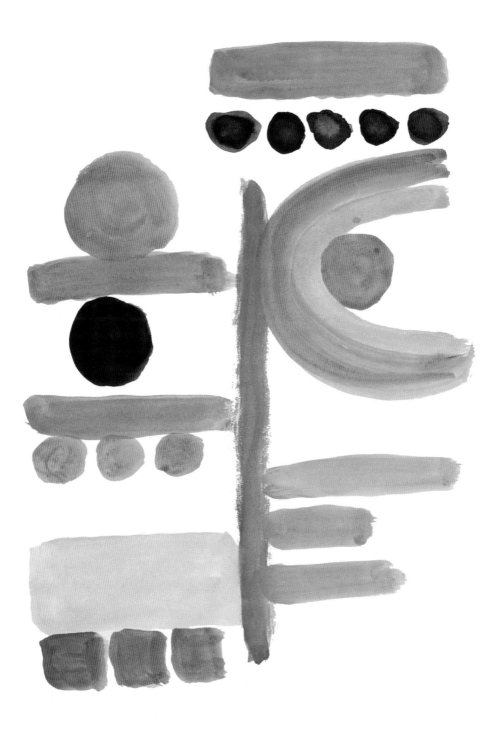

Week 2: Abstract Drawing in Color

Materials: 11" x 17" drawing paper. #6 and #12 round brushes. Tin of opaque watercolors. (Pastels. Markers. Crayons.)

TIP: *Working with just a few colors can help us create rhythm and order in our work. Limitation is liberating. Less is often more and working with less can help us create clarity in our work. For inspiration, check out the art of Brice Marden.*

This is the same exercise as the last but offers us the chance to explore color. We can research color theory online, if we like, but here we'll work in an instinctual way like kids do. Most of us have an innate sense of color and it will develop as we go forward. In our club, we mix our colors right on the cakes of paint in the tin rather than take the time to mix on a palette. At the end of our session, we simply wash the tin of paints off under the tap. It's good to know that we can tone colors down by adding burnt umber to them. Also, the less water we have on the brush, the more vivid our colors will be. Use a scrap piece of paper to test colors.

Again, we'll put on some music and begin to make marks with the brush and paint. (Over time, try the exercise with all of the mediums listed above.) Explore making marks of all sorts with the brush in color. We may want to begin with just two colors then add more later if it seems interesting to do so.

Break the time into thirds and pause after each round to share and get inspiration from each other. Notice how different the drawings all are.

NB Often when we're beginning or uncertain we work only in midtones and play it safe. Contrast gives our drawings real energy. In opposites, we'll also find truths. Drawing by drawing, we'll find ourselves making order or sense from our random marks. We can just let this happen and respond to inspiration in the moment as ideas come to us. Coherence will assert itself even though it may take a dozen drawings before something interesting happens. Note also that we can return to this kind of drawing over and over. Each time, we'll do something different.

Drawing in this way gives us great fluency with our hand.

Mo Cook—opaque watercolor brush drawing

—opaque watercolor brush drawing

Week 3: Blind Contour Drawing

Materials: 11" x 17" drawing paper. Fine marker pen. Pencil. #6 brush. Tin of opaque watercolors. Colored pencils. Packaged objects such as yogurt containers, water bottles, tins of sardines, etc. (Anything with lettering will do.) Photographs of people.

TIP: *Watch for any tendency or need to get things "right" and try to let it go. For inspiration, check out Cy Twombly's large gestural paintings.*

Set a single packaged object in front of each person and use pencil or marker to start. A contour drawing is *outlines* only, no shading. In *blind* contour drawing, we look only at the object we're drawing and *not* at our paper. Not even a glance! We try to co-ordinate our hand and eye. We can even draw the lettering.

Try doing several drawings like this, comparing results after each. The drawings will be inaccurate, of course. But, if we look with care, we may see that they are often full of life, even assurance. And, because we're working with others, we may well see the individual hand of the artist as we compare. The mind doesn't interfere when we draw like this. It doesn't tell us things should be this way or that way, or that we're missing the mark. We're more present, just drawing, and often something pure and singular comes through. In time, we want to bring this singular quality into all of our work.

Now, try doing a proper contour drawings of one of the objects. A contour drawing is outlines only, no shading. Compare these drawings with the *blind* contour drawings of the same object.

We can try adding a little color to some of our blind contour drawings using colored pencil and trying to keep the same loose quality.

Later, we can try making blind contour drawings of people too. It's a great way to warm up and get to know our subjects while gaining confidence in our hand.

NB We can achieve a sense of freedom in our drawing when we let go of the need to get things "right". The more we do, the more able we become. We can return to this kind of drawing over and over. It can be like a meditation and teaches us to just be present and to focus. Drawing helps us grow what Yoga calls one-pointed focus in which we forget everything but what we're doing. We can bring this quality into our whole lives.

—marker and colored pencil drawing

—colored pencil drawing (blind contour in blue)

—colored pencil drawing (blind contour in blue)

Blind contour drawing is one of our key practices. It teaches us to really look at our subject, focus and develop assurance in our hand. We can also practice by making regular contour drawings on top.

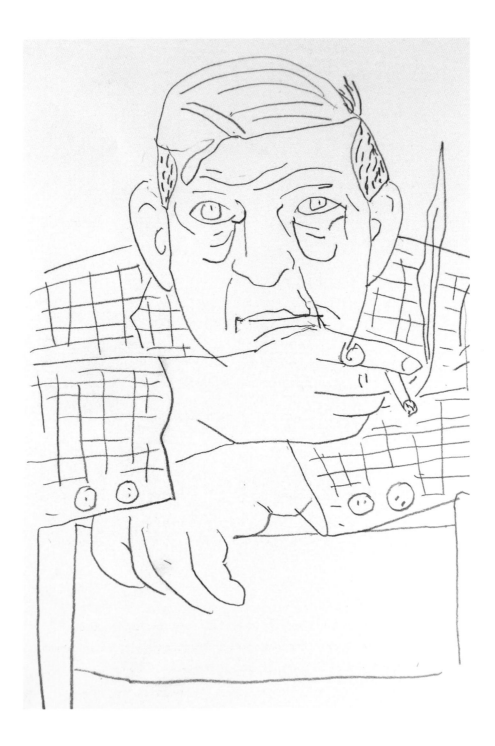

Week 4: Observational Contour Drawing in Black and White

Materials: 11" x 17" drawing paper. Drawing pencils (4B or darker). Charcoal. Fine marker pen. Brushes. Tin of opaque watercolors. Photographs of people.

TIP: *Vine or twig charcoal is lighter in tone than stick charcoal. If used lightly, it will erase. For inspiration, check out Matisse's beautiful, simple portraits online.*

Again, contour drawings are just the outlines, no shading. We can use pencil, charcoal, pen, or brush and black paint. These different tools will yield different results. In pencil drawings the lines will be fairly uniform thickness though may vary in tone. Use a 4B or darker pencil and press firmly, holding the pencil near the lead as if writing. Pencil drawings can be more accurate and subtler than heavier brush drawings. In charcoal and brush drawing, we can vary tone and the thickness of the lines to achieve dramatic results. Experiment with both over time.

Whatever tools we use, making contour drawings saves us from getting muddled in the details of shading. We can work on that later, if we like. Contour drawing is a great way to practice. When we have an idle moment, we can pick up our pencil and draw like this in a sketchbook.

We might want to begin the exercise by doing several blind contour drawings first. They'll get us to look with care at our subject and internalize what we see. After we've made a few drawings like this, we can proceed to making our contour drawings. We still look at our subject, but glance at our paper too. How much we look at each is something we can experiment with. In drawing, we're not only using our eyes but our memories too.

Sometimes our contour drawings seem stiff at first, especially in comparison to our blind contour drawings which can have so much life in them. In time, we can bring the free spiritedness of our blind contour drawing to the greater accuracy of our contour drawing.

NB Sometimes we look so much at our subject that we loose connection with our drawing. Step back and look at your drawing as you go to keep the *whole picture* in mind. To be more fluid, look at where the hand *is going* rather than where it *is* in the moment.

—pencil drawing of W. H. Auden

Week 5: Observational Contour Drawing in Color

Materials: 11" x 17" drawing paper. Vine charcoal. Drawing pencils (4B or darker). Colored pencils. Pastels. Brushes. Tin of opaque watercolors. Objects for a still life—for example, water bottle, potato, pencil; or a vase with flowers; an orange, lemons, tea towel and so on. Photographs. (Anything will do.)

TIP: *If using colored pencils, choose good ones with rich colors. Cheap colored pencils are often hard and less brightly tinted, offering less dynamic results. Check out David Hockney's colored pencil drawings for inspiration.*

Following on from the last exercise, we'll now make contour drawings in color. There are many ways of doing this and we can experiment. In drawing flowers, for instance, we might begin by making brush contour drawings in a pale color using our watercolors, then go back in and add splashes of color for different parts of our drawing. To keep our drawings alive, we can let go of any sense that we need to be entirely accurate. Let's start loose and have fun. Breaks in our lines give a lot of energy to our drawing and give the eye a way to enter a drawing and roam around.

Sometimes I ask myself what drawing is for. If I really wanted an accurate image of a plant, I'd take a snapshot. What I want in a drawing is to be drawn in, to be able to loose myself in both the subject matter and the energy of the drawing itself. Or perhaps in beauty or some kind of quirkiness. A little ambiguity can be a good thing; it gives some space for the mind to play.

We can invent many other ways to explore. We might paint the basic shapes of the subject first, in flat color, then add finer contour lines with brush and paint or in colored pencil or pastel. Or we might do our whole drawing in pastel, smudging shapes first then adding lines with the sharp edge of our pastel. Or we might do our whole drawing in colored pencil. We might try to use lines to define shape and other details of our subject rather than do an outline and color it in.

NB Remember there are no hard and fast rules. We can bend all the elements of art-making to do what we want. We're here to explore and discover what works for us and how to make drawings that reward frequent viewing.

—colored pencil drawing

—opaque watercolor, colored pencil and conté crayon drawing

Week 6: One Color Portrait Drawing

Materials: 11" x 17" drawing paper. Pencil. #6 brush. Tin of opaque watercolors. Several good black-and-white photos of people. (The photographs of American photographer Richard Avedon are superb for this and can be found on the Internet.)

TIP: *Practicing making brush lines before diving in gives our hand confidence. We'll also have a better sense of how much water to use on our brush to achieve tone and strong lines. And we'll see how to vary the pressure on the brush to alter line weight. If we're new to portrait drawing, we may want to check a diagram for facial feature placement online. With practice, we'll internalize where things go.*

To warm up, make at least six contour drawings in *pencil* of the subject in the photograph. Be loose and work fairly quickly, trying to capture the overall shapes rather than fussing with details. Then look and see how close these are to reflecting the subject.

Next, practice making brush lines.

Then, make a blind contour portrait drawing using brush and watercolor in your chosen color. In a blind contour drawing, we won't look at out paper, only at the photograph. Our drawing will be loose and full of mistakes but will likely be lively. We'll come to know our subject better and gain skill when we loosen up in this way.

Finally, make a brush portrait, making a few simple tones for facial shape first then adding lines for details like hair, nose, mouth, ears and eyes. Keep it simple and keep the big picture in mind, watching for any tendency to over-focus on details. Drawing people takes practice and the only way to learn is to do. When we look at our photographs, we want to see if we can heighten awareness of whatever speaks to us in our subjects. Try exaggerating features to bring them into sharper focus.

Display the drawings and discover what works in them.

· · · · ·

Another week, we might try one color drawing in crayon, pastel or colored pencil. We might also add a second color making it a two color drawing.

NB Working with limitation helps us let go of being literal and gives us ways to describe what we see with greater clarity and force.

—opaque watercolor with dry brush drawing

Week 7: Portrait Drawing

Materials: 11" x 17" drawing paper. Pencil. Colored pencils. Charcoal. Brushes. Tin of watercolor paint. Several good black-and-white photos of a people. (Plenty of good pictures can be found on the Internet.)

TIP: *After warming up with contour drawings, dive right into making a portrait. Warming up first helps us keep fresh life in our hand and not get stuck on perfection.*

To warm up, as in the previous exercise, make a few blind contour drawings and contour drawings of your subject. Be loose and work fairly quickly, trying to capture the overall shapes rather than fussing with details. Then look and see how close these are to reflecting the subject. Working like this helps us internalize the feeling of our subject.

We can try making portraits using different materials—pencil, charcoal, paint, colored pencils or even monoprint. Experiment to see what suits you best.

For both paint and charcoal, we can try laying basic shapes down first then going back in with line. We can mix mediums too. For instance, we could make a watercolor portrait then add lines in colored pencils. Or we could draw in pencil first and add watercolor washes after. Or, if working in charcoal, put down smudgy shapes first then go back in and add detail. It's often helpful to think of the big picture first then add detail later.

Not all details deserve the same attention. For intance, it's not possible to draw every hair or eyelash. We want to aim for an impression or feeling of the person and choose details that say something—smile lines around the eyes, tousled hair, trousers a size too large. Or we might focus on an attitude as revealed by an upthrust chin or downward cast eyes.

It can also help to not worry too much about getting a great likeness. That comes with practice.

NB A lot of our drawing comes from memory. Looking with care and making practice drawings helps us keep a vivid impression in mind. Our drawings might also be more accurate and alive when we rely on an inner impression after careful looking.

—opaque watercolor and colored pencil drawing

—opaque watercolor and colored pancil drawing

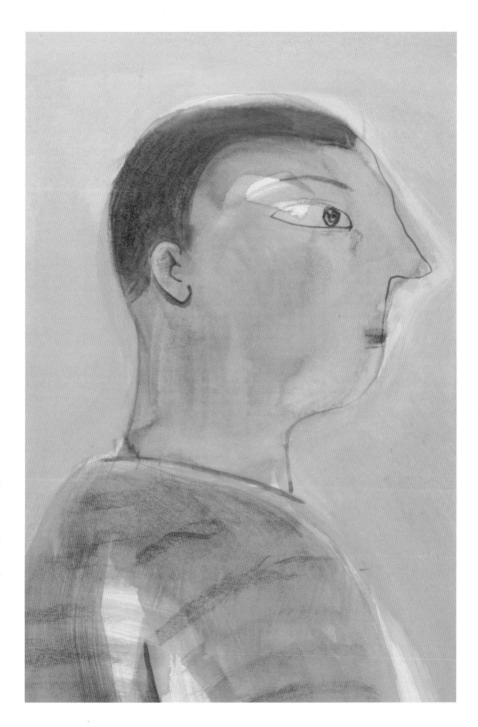

—opaque watercolor, conté crayon and pencil drawing

Week 8: Drawing from Imagination

Materials: 11" x 17" drawing paper. Pencil, pen, brushes, watercolors, or any drawing tools we like. Objects for reference, if desired: for example, a teapot, paintbrushes, a shoe, a hat, photos of dogs and people, and so on. (Anything will do.)

TIP: *If we draw like this a lot, we can develop a style of our own.*

A free drawing day. Fill page after page with drawings! We'll start with pencil but not use erasers, just draw. If it doesn't look like we want it to, we can draw it again, and again. Just draw and draw.

Next, we can try pen. Just draw. Draw hats and fill a page, hat after hat. Draw shoes and shirts, pants and jackets. Draw people. Just draw.

Now try drawing with a brush and paint. Start with black and vary the tone of the line, dark to light. Draw the hat again. Have fun with it. Experiment by using dry brush techniques, adding almost no water and blotting the brush on a paper towel after getting paint on it and before painting. We can also try using very wet brushes and adding color to color on the painting itself. We can play around to see what feels interesting to us.

Drawing from imagination is play but not always playful. Picasso made some fierce and powerful drawings this way. Imaginative drawing relies on memory. It's not a slavish attempt to replicate what we see but a way to say something about it. It can be expressive in many different ways.

NB Lots of adults have trouble drawing from imagination. Unlike kids, we seem to lose the ability to simply plunge in and play. Doodling can help. Also we might try drawing onto one large piece of paper day after day. Just walking by and adding drawings of anything we feel like until the paper is black with marks and images. When we mess up the paper, we might feel more free to explore and expand.

Once we get going, something will begin to assert itself. We'll discover our own way of drawing from imagination and how we can develop it. This kind of drawing also takes practice but the freedom we find in it can be brought into all we do.

Maggie Stern—stitched drawing on sweater

I feel really good on the days I remember to smile and take the trash out.

—ink and pencil drawing

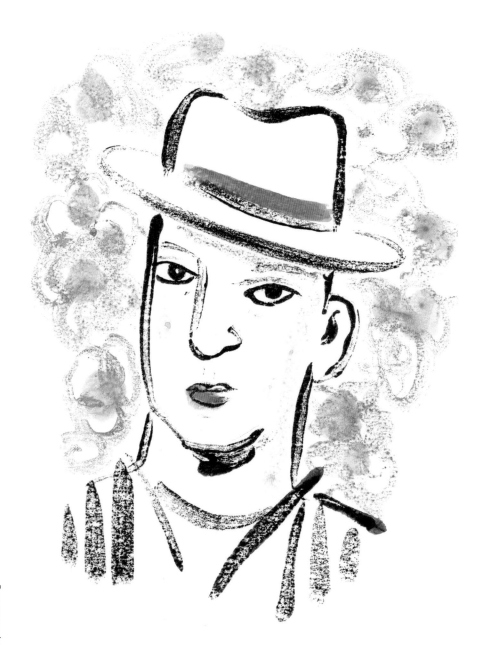

—monoprint drawing

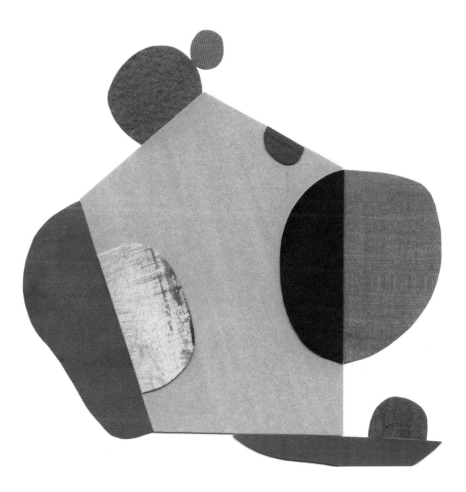

16 Session 2

Trying Things Out

In this session, we'll get out of our comfort zones to explore creative thinking. We'll draw together, simplify, exaggerate, embrace awkwardness and see what's possible.

Week 1: Painted Paper Abstract Collage

Materials: 8.5" x 11" paper. 11" x 17" card stock. #4 and #6 brushes. Tin of opaque watercolors. Scissors. Glue stick or acrylic matte medium.

TIP: *Cut-paper collage is drawing with scissors. For inspiration look at the cut-paper work by Matisse. They are large in scale and full of inspiration.*

First, spend an hour or so painting approximately 30 six-inch squares of color on drawing paper. Make a few bigger ones. To master getting solid colors, here are some tips: don't use too much water on your brush or the colors will be insipid. Mix colors right on your paint tin. Paint the color onto the paper in one direction, continually applying paint as needed. Then apply more of the color and brush it in the opposite direction to make it richer. Keep going back and forth until you have a rich, flat color. Adding a bit of burnt umber will subdue colors. Make some rich blacks using blue, red and deep green.

Next, take a sheet of the card stock. Cut the colored paper into shapes, organic or geometric, or both. Arrange in a pattern before gluing down. Explore light and dark; see ways to balance and disrupt composition; play with how shapes speak to each other; and notice how they work together to make a coherent whole. Try to add an element of surprise. What can we do to make our abstract collage feel vital and alive? Leave some white space around the image. Make 4 or 5 of these collages, variations on a theme.

NB Working in this abstract way helps us consider some basics in our art making such as color, contrast and composition. We're looking to make something that has coherence but also that offers some surprise so we can draw the viewer in. We can consider exaggerating to create boldness or surprise. Exaggeration will create clarity too.

—opaque watercolor painted paper collage

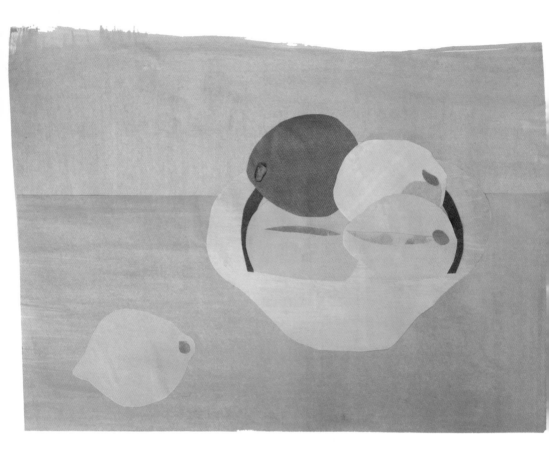

Week 2: Painted Paper Collage Drawing

Materials: 11" x 17" drawing paper. 11" x 17" card stock. #4 and #6 round brushes. Tin of opaque watercolors. Scissors. Glue stick. Flowers.

TIP: *Check out Mrs. Delany and her exquisite botanical painted paper collages from the late 18th century. They're more elaborate than what we'll do but are an inspiration.*

In this exercise, we'll be drawing with scissors. For the first hour or so, paint 6" to 8" squares of color on drawing paper as we did in the previous exercise. Be inspired by, but not slavish to, the colors of the flowers and make some greens and black. It can take some time to master getting solid colors and the end results will be best if our painted colors are solid and deep, and without brushstrokes.

Using the flowers as inspiration, cut out a selection of simple flower shapes or a larger one with details such as stamens and varied coloration. We're not making the accurate botanical drawings Mrs. Delany did, but imaginative drawings using flowers as inspiration. Feel free to exaggerate or change the actual shapes. If making a large single flower, we might want to cut out shapes of color for shading and detail. Cut out leaves. Again, make up the shapes if you like. Cut out stems and perhaps a vase for the flowers to sit in. Or not. Perhaps a large flower alone is what you are after. Anything goes.

It's best not to think or plan too much but just dive in. Here is a chance to simply follow gut instincts and work quickly.

Assemble and design your image on the card stock. Pick up the pieces one by one to glue. Using a scrap piece of paper, turn your pieces upside down to apply glue and take care to get the glue on all the edges. While glue sticks work fine, if care is taken, using acrylic matte medium and painting it on with a brush may be easier and more permanent. Place the shapes roughly where you had them on the card stock and press down.

There may be time to make a couple of these painted paper collages. We can branch out into other subject matter too.

NB Drawing with scissors keeps us from getting too fussy, unless we are Mrs. Delany, who delighted in details and worked with embroidery scissors. It also gives us a chance to work simply and in bold, declarative ways that we can bring into other ways we make art.

Sally Young —opaque watercolor painted paper collage drawing

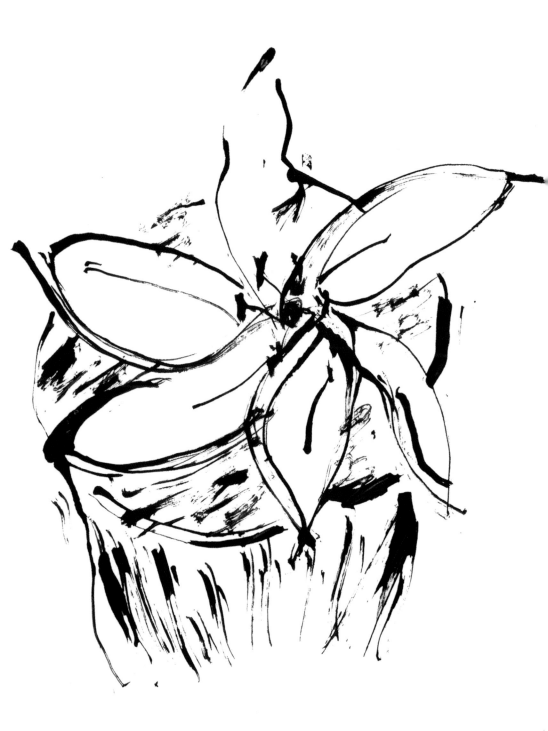

Week 3: Using Awkward Tools

Materials: 11" x 17" drawing paper. Black acrylic or poster paint. #6 round brush. Twigs of various sizes from 1/8th" to 1/2" cut from a bush or tree. Various vegetables, such as cabbage, potato, beets with greens and carrots, plus a tea towel and spoon. Disposable palette paper or a plastic palette or saucer of some sort for paint.

TIP: *Using awkward tools ensures that we'll make bold drawings. In The Saturday Morning Drawing Club, we almost never use erasers. If we make mistakes, we just carry on. This practice encourages us to experiment and see what happens.*

First arrange a still life with three objects on the tea towel. Now make a contour drawing of the still life using the brush. As the brush is a fair size, it's not possible to get fussy. Allow awkwardness and see if it's possible to describe the still life in broad strokes. Try to use deep, rich blacks as well as pale gray tones. It will be helpful to water down acrylic paint in a small plastic cup so it's fluid.

Experiment using dry brush techniques in which very little water is used on the brush. After cleaning the brush in water, dry it on a paper towel before dabbing it in the paint. It takes practice to get a sense of how much water and paint. Dive in fearlessly and try it all out on scrap paper.

After making several brush paintings, rearrange the still life and draw using twigs dipped in paint. Again, it will be difficult to draw in too careful a way. This is a way to invite in "accidents" and to work with what appears on the page as we go. It asks that we respond to what's happening in the moment rather than get too attached to what we think ought to happen.

NB When we experiment, we don't know what the end results will be. It helps in our art-making that we can let go of old habits at times and be fully present to inspiration as it arrives. Working with awkward tools and experimenting in different ways encourages a spirit of adventure and teaches us to be intrepid. It keeps our curiosity alive. If we ever notice a feeling of dullness, we can make up an experiment and see what emerges for us. To make an experiment, consider exaggerating some element of the work—scale, color, dark and light, form, movement. The wilder the experiment, the more we can discover!

Mo Cook—twig and poster paint drawing

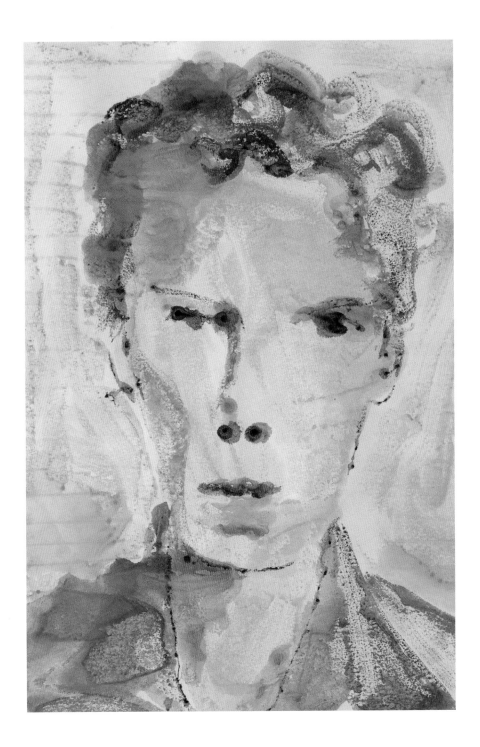

Week 4: Monoprint Portrait Drawing

Materials: 11" x 17" drawing paper. #6 brush. Tins of opaque watercolors. Disposable palette paper. Sheet of 9" x 12" thin Plexiglass from a hardware store. Tin of opaque watercolors. Photographs of people.

TIP: *Using photographs of real people is much more interesting than the air-brushed models used in advertising.*

There are several kinds of monoprint drawing. In this exercise, we'll do a contour drawing of our subject then lay a sheet of Plexiglass on top and tape it down. Then we can tape our drawing paper to the top of the Plexiglass so it can hinge up and down.

Using our opaque watercolors, we will next paint a small portion of our image on the Plexiglass using our initial drawing as a guide and our photograph to reference color. Paint quickly then press the good paper down on the painted Plexiglass to make an impression and lift it up again. Proceed in this way until the whole image is complete. It may be necessary to experiment with the weight of the lines and the amount of paint. Make several of these drawings and compare results.

Another way to make monoprint drawings is to ink the Plexiglass with relief printing ink using a brayer—a roller to spread the ink thinly on a surface. Then place a piece of drawing paper on top and draw on it with a pencil or the tip of a knitting needle. This will give a textured line drawing. You can rub your hands on it also to create tone.

Both kinds of monoprint drawing release us from fastidiousness so that we can create a drawing that gives an impression of our subject and is full of the kinds of ambiguities that draw a viewer in for repeated looking. As there's no way to work with total accuracy with this technique, we'll get a chance to work in a looser manner and with "mistakes". Monoprint drawings will have lots of texture and life. They're suggestive rather than literally descriptive. Again, we can exaggerate color or form for effect.

We can also try putting our photograph under the Plexiglass and using it for a guide. The results will likely have more realism.

NB We willl need to work fast in this kind of drawing as the paint dries quite quickly. This is good training in simply diving in and seeing what happens.

Karen Trittipo—monoprint drawing of Benedict Cumberbatch

Week 5: Simplifying

Materials: 11" x 17" drawing paper. #4 and #6 round brushes. Vine charcoal. Tin of opaque watercolors. Several photographs of different people. Objects.

TIP: *To simplify, think in terms of the big picture and letting go of some details.*

Sometimes, when we draw, we get a bit mired in the details and lose sense of the whole. We can simplify in order to make our vision clearer. What matters to us when we look at our subject? What do we want to show? And how can we let our own spirit shine through? Keeping it simple will help.

To simplify, step back and think of the big picture. It's the big picture art is after. It can be hard to see it with too many details or when we don't bring consciousness to every mark we make.

We can practice simplification with any subject and with all aspects of drawing too. How many marks do we need to make to say what we want to say? Less is often more. When we keep simplicity in mind, we'll give purpose to the marks we make.

Let's try making some drawings of complex subjects keeping the idea of simplifying in mind. And, when we think about it, everything is complex, even a tiny acorn. What can we leave out? Simplifying is a way of distilling our impressions to make things clear and give space for our spirit to enter the drawing too.

NB There are many ways to make drawings of the same subject matter and it's worth trying different approaches to find what best reflects you as well as your subject. Simplifying helps us see the whole and not get stuck in the details. We can't give equal weight to everything and there's lots we can leave out. What matters is that we choose what we want to emphasize. Practice will give us a surer hand and, in time, our drawings will have both life and likeness.

Experimenting with different approaches will give us ideas. We can forget about the finished product and just see what emerges when we try things out. We want to be intrepid explorers.

—opaque watercolor brush drawing

—opaque watercolor and colored pencil drawing

—digital drawing

Week 6: Drawing Still Life

Materials: 11" x 17" drawing paper. 11"x17" hot press (smooth) watercolor paper. Pencil. Brushes. Tin of opaque watercolors. Fruits, vegetables, tin of sardines, package of tea, domestic objects or whatever comes to hand.

TIP: *When we make observational drawings with paint, the line between drawing and painting can disappear but the impulse is the same—to observe and render.*

Arrange the elements of the still life. We can light this to give more definition to shadows, if we like, but it's not necessary.

Warm up on drawing paper by making quick contour and blind contour drawings, looking with care at the whole and at the spaces between objects. Practice drawings such as these make us look with greater care at our subject. The more we look, the more we see and the more we memorize what we see. Using our memory as we draw can help give our drawings life. The more we draw, the greater the fluidity of our hand. It's well worth making practice sketches first.

Next, we'll move on to our watercolor paper. Pricey paper can dampen our sense of freedom but our attitude will be one of faith. First, sketch out the drawing in light pencil. Then dive in and paint first lightly in shapes, strenghtening color as needed and adding details with line. As always, try to think in terms of the whole image and try to keep the same approach throughout the whole. If we're including commercial products, we can draw the type on packaging. In still life, we can choose details that are telling.

NB Still life drawing and painting can be a simple appreciation for what is in our lives. It's often a humble art but can be a profound one too. Italian artist Giorgio Morandi arranged and painted glass bottles every day in his studio for forty years. These simple paintings are quiet meditations that reflect time and mood.

At the end of our exercises, when we *look and see*, we always have a chance to reflect. We might look at what we're trying to convey in our still lifes. A sense of vibrant life? Crass commercialism? Appreciation? There's a lot we can do with this traditional form. We can think about how we can bring it into the here and now and how we might bring our work into conversation with other artists working today in this vein.

Sally Young—pencil and gouache drawing

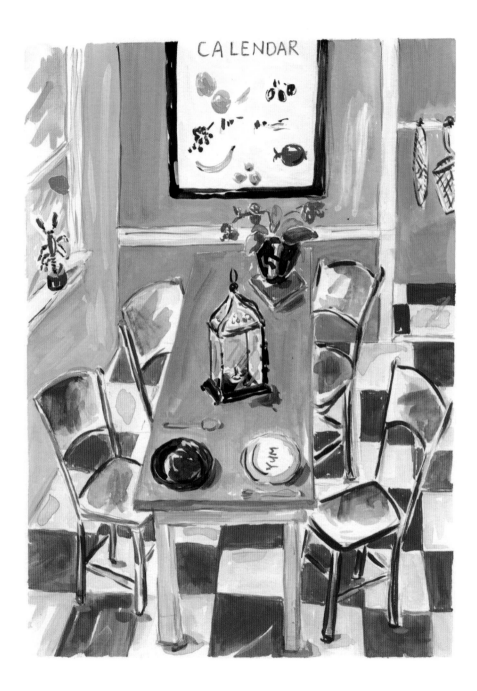

Week 7: Drawing Interiors

Materials: 11" x 17" drawing paper. 11"x17" hot press (smooth) watercolor paper. Pencil. Sketchbook. Brushes. Tin of opaque watercolors. Colored pencils.

TIP: *When drawing place, focus on the big picture and simplify the details. Check out Van Gogh's paintings of interiors for inspiration.*

Drawing and painting the space we live in gives us a record of our lives at a certain period in time which we might enjoy later. It can be a way of appreciating how we live too.

For the purposes of our club, we can first make sketches at home in our sketchbooks before meeting. We might choose a few cherished objects or draw a whole room. We can draw the people in the room too, if we like.

Some of us may have issues with perspective or the angles of chair legs. When geometry enters into our drawings, we might feel we need to be more faithful to it than to the essence of the space. We can think of Van Gogh here and the way he altered what he saw. We want to give an impression of our space and our lives rather than make a rigid architectural drawing.

We can make loose pencil drawings to start. To really loosen up, after doing a few sketches, try doing a couple more with your eyes closed. Yes, eyes closed! We are simply working from pure memory and we'll get a very distilled, loose drawing which may be helpful when it comes to the next step.

At our meeting, we can take our loose sketches and make them into colored drawings using watercolor or colored pencils. Try doing one of each, keeping things as free and lively as we can.

NB If our drawing doesn't work, we can try again. The more we forget trying to get things "right", the closer we'll come to a true impression.

Sally Young—pencil and opaque watercolor drawing

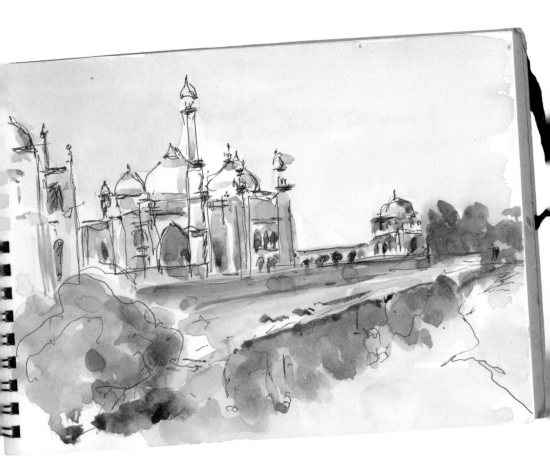

A sketchbook can be a travel journal, a record of the places
we've visited and the things we've seen. Or it can be a place
to simply imagine.

Week 8: Sketchbook

Materials: An 8.5" x 11" sketchbook. Drawing pencil. Vine charcoal. Sharpie® medium-tip felt drawing pen. #6 brush. Tin of opaque watercolors. Colored pencils. Scissors. Glue stick. And any other drawing materials that strike your fancy!

TIP: *A sketchbook is a place to explore freely. We can use it any way we want to.*

Start by opening a new sketchbook. Flip through the blank pages and feel how they might be a diary of what we see around us, of ideas, and explorations.

Sometimes a pristine sketchbook intimidates us with its newness. Too many of us have unused sketchbooks lying around. So, let's take a pencil and make marks in the book, randomly and with eyes closed. We can just go for it. One of these pages may soon hold a good idea or a well-observed drawing. Still, let's muck it up a bit and lose the preciousness. Whatever brilliance we have in us, there's lots more to come; it's not going away. We needn't fuss or hold on to what emerges from our pencils. By diving in, by not caring where the far shore is, we'll swim in the stream of invention.

Now that we've mucked up our book, let's inscribe our names on the front page and the date of beginning. This is a record of where we are right now. It can help us as we make our art.

Sketchbooks unfold over time. First, we can go out into the world now and make observational drawings, whatever piques our interest. Quick sketches. Loose. Even inept. Awkward is good.

Later, we can get our paints out and play in whatever way we want to. It's a sketchbook, and we're making it ours. We can draw from imagination.

It's great to draw in our sketchbook every day. It can keep us engaged with drawing. When we finish one sketchbook, we might buy another, just one. Small steps are the ones that take us somewhere. Let's keep pace with what we have.

NB In time, our sketchbooks may become places in which we work out ideas for our art, make notes, and develop ideas, record things. They can be our sanctuaries of inspiration. We can keep them for a while to see how things develop. And we can let them go too. Whatever we do, there is always more to come. Letting go can be liberating.

Sally Young—pencil and watercolor of the Taj Mahal in India

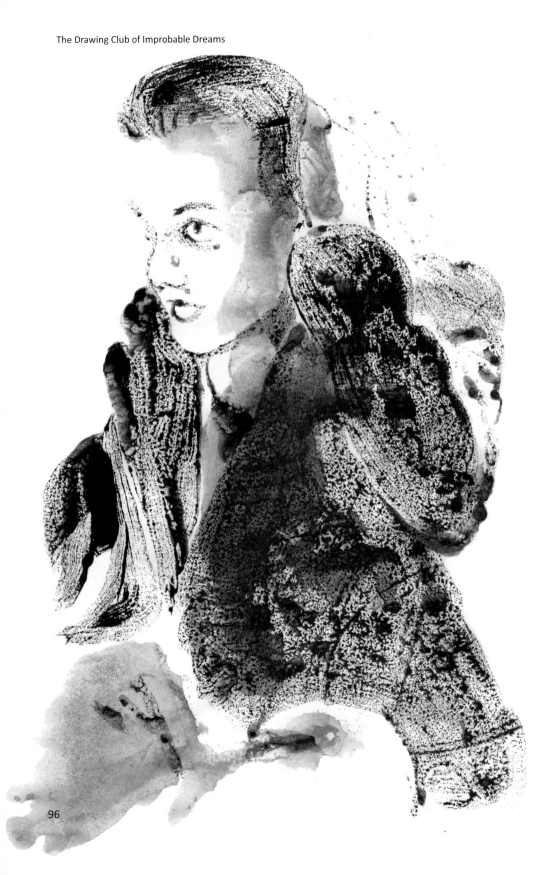

17 Session 3

Stepping It Up

The way we choose to make art springs from who we are. Our stories matter and everything in them, both the incident and the incidental. In this session, we get to know ourselves a little more, build strength and get ideas for our paths as artists.

Week 1: Up the Scale

Materials: 24" x 30" drawing paper or larger. Newsprint. Vine charcoal. Selection of brushes. Black water-based paint. Tin of opaque watercolors. 24" x 30" Plexiglass for monoprint drawing. Photographs of people.

TIP: *Working on a large scale can free us up. We get to exercise our courage.*

To warm up, begin by making blind contour drawings of your subject in the photograph with vine charcoal on large newsprint. Then make several contour drawings, taking time to look at each drawing afterwards to see how it's working. Making rough, even messy, sketches first is like trying on different shirts or dresses before we head out to a fancy dinner. We need to see how things look before we step out. We'll see it doesn't really matter. We look fine in jeans, too.

When we have a drawing we like, we can tape the Plexiglass to the table over the sketch. Tape the good drawing paper to the top edge of the Plexiglass so it can hinge up and down. Proceed to paint on the Plexiglass using the opaque watercolors then pressing the good paper down to make an impression. Work quickly in color or black and white.

Another option is to draw with vine charcoal onto the large paper. Vine charcoal erases easily so is a good option for underdrawing. Proceed to draw with a brush and the opaque watercolors. Mostly, we'll need bigger brushes when we work on a larger scale.

We can up the scale, of course, with any kind of drawing. Try different ways.

NB When we work big, we get a chance to step into boldness. It doesn't matter if we get it right the first time; what matters is that we dive in. Make your lines strong and declarative. A grand mistake is better than a tepid one.

—monoprint drawing with opaque watercolor

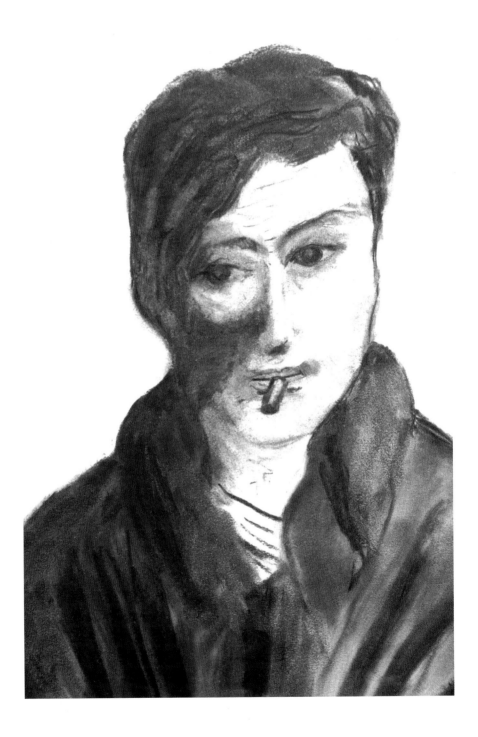

Week 2: Drawing with Black

Materials: 11" x 17" card stock or hot press (smooth) watercolor paper. Brushes. Black gouache, acrylic or poster paint. Plants and/or photographs to work from.

TIP: *There are many ways to explore working with blacks. Check out American folk artist Bill Traylor who makes great use of black forms in his enchanting work. South African artist William Kentridge uses deep blacks in his charcoal drawings. And American artist Cara Walker uses innocent looking black cut-paper silhouette art to make powerful statements about black American history.*

Strong blacks can encourage our bold selves to step forward. We can shuck off our good manners with black and go deeper. Sometimes we get stuck in the middle ground of grey or tepid color. Black can add dramatic contrast to our drawings so they invite the viewer in. And it can evoke drama and mood too. Whether we're making simple line drawings or smudging charcoal, black makes a statement.

Let's see what might emerge for us when we draw with charcoal or black paint. Our focus is on making our blacks rich and dark. We can all have a tendency at times to hover in the middle grounds of muted colors and greys. There's nothing wrong with this but we can also give ourselves the chance to explore punching things up.

We can draw in lines and also in shapes. If we're using charcoal, we can go back into it and make white lines with an eraser if we like. If we're drawing with brush and paint, we can try making silhouette drawings—big black forms of plants, animals, birds.

Some of us may also want to try making cut-out silhouette drawings with black paper. We'll need both scissors and an X-acto knife for this approach, and glue to paste down the results on card stock or some other surface. This is a more graphic and detailed approached that might appeal to some of us.

However we work using black, we want to experience our own boldness.

NB When we work in bolder ways, we create a lot of energy in our work and it will draw the viewer in.

Deb Kaup—charcoal drawing

Week 3: Over and Over

Materials: 11" x 17" drawing paper. Colored pencils. Flowers, twigs, leaves, etc.

TIP: *Practice gives us the skills to bend our drawing to our will.*

In traditional Chinese art education, students are encouraged to draw the same thing over and over again until they've internalized how something like bamboo, for instance, can be rendered in a convincing and economical way. It gives them great confidence in their hand and allows them to work towards the whole without getting bogged down in the details. We can practice this way too.

Take your flower or a leaf and just start drawing it on the paper. Draw it many times over on the same paper. There's no need to sketch first but simply draw and see what arrives on the paper. This is good practice in letting go of hesitation. It's also good practice in discipline—just sticking with things. The more we practice, the more we're able to convey what we want to with some ease.

We can apply this practice to drawing any object or drawing people too. Over and over. Doing things in a repetitive way might seem dull at first but we soon begin to internalize how to draw things. Our hand develops a memory and becomes more assured.

This is a meditative exercise that teaches us to *focus* and be fully present with what we're doing. It's a great opportunity to notice thoughts that come up and gently let them go, always returning our attention to our hand on the paper and what we're doing. Drawing can be a kind of yogic practice in this way. We learn to be more present and more disciplined about our minds, valuable tools that will help us in our art-making, and life too.

We can try altering our approach by changing the tools with which we're drawing or adding color. Again, our goal is to draw our own way of drawing.

NB While this may seem like simple drawing practice, it's also practice in perseverance. It's a good thing to know how to fall back on perseverance when challenges arise in our art-making. And they will! Carry on!

—brush and pencil drawing

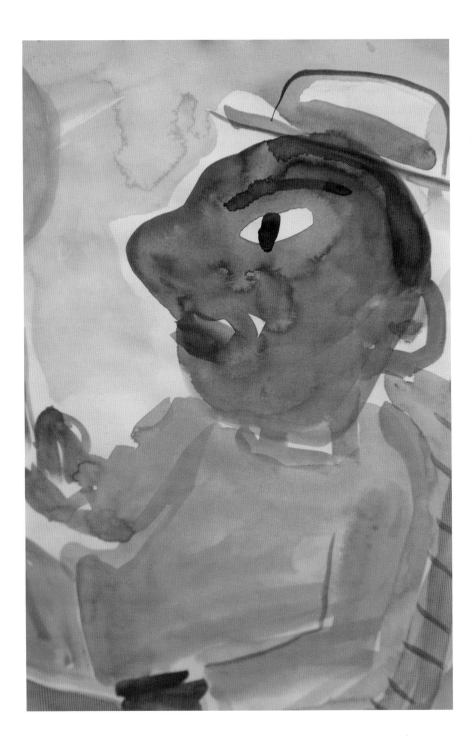

Week 4: Splash Around

Materials: 11"x17" or larger drawing paper. Pencils. Markers. Crayons. Colored pencils.
Brushes. Tin of opaque watercolors.

TIP: *We don't need to know everything when we begin to draw or make art. Our process can be one of diving in to explore and discover.*

Some of us are content to draw what we see and settle on a way of working that suits us. Some of us are interested in discovering new ideas. All of us will want to keep our eyes and minds fresh and open to new experiences. Whatever our personal goals, it can be fun to splash around once in a while.

I can remember times when I simply didn't know what I wanted to do next. There are times to lie fallow and let new ideas build. Sometimes I would sit in a chair in my studio and *think*. I had many ideas. They descended like raindrops but it didn't help all that much. How should I choose? Half the time the raindrops just washed away, gone forever. But sometimes I simply went to my drawing table and started splashing around. My drawings were often childlike, or simply scribbles. I enjoyed myself.

We don't always know what's waiting to be expressed and explored. There can be times of waiting between bigger projects or explorations, times of "un-knowing". But we can keep our hand in. This is a moving meditation, drawing, daubing color on loosely, without concern for making anything. Just drawing and seeing.

We can work from our imaginations here or in abstract ways. Have a stack of paper, work quickly and go from one drawing to the next without fussing or thinking. Forget everything and let drawing take over. What shows up on the paper may lead to ideas for our art, more assurance in our hand or simply be a meditation in which we free ourselves from the constrictions of having to succeed. We can just have fun and enjoy the feeling of freedom. That feeling will grow and come with us where we go.

NB It can be so helpful to take the time to simply play around. As we draw we may get the chance to see where we are, where we've been, and where we might like to go. Our goal is to make art that can only be ours. We can let whatever wants to emerge step forward. There's only one you. Or, as Oscar Wilde said, "Be yourself. Everyone else is taken!"

—opaque watercolor brush drawing

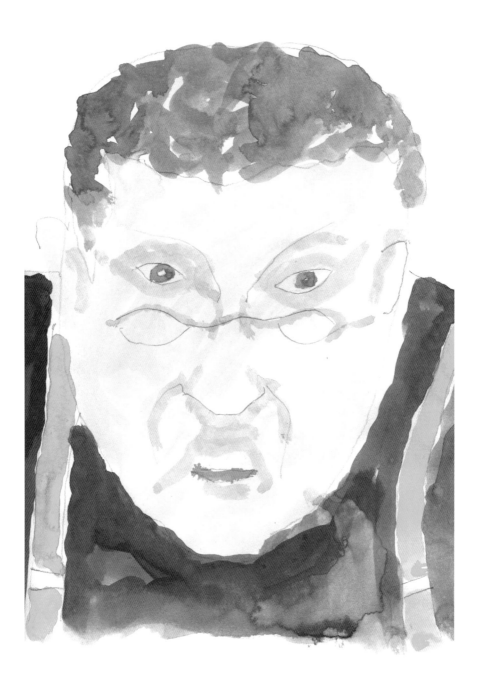

Week 5: Portrait of an Artist

Materials: Vine charcoal. 22" x 30" newsprint. 22" x 30" hot press (smooth) watercolor paper. #4 and #6 round brushes. Tin of opaque watercolors. Photo of a well-known artist such as Ai Weiwei, David Hockney, Andy Warhol, Matisse, Picasso and so on. (It can be fun if we all do the same one.)

TIP: *Using different materials can change what we convey in our portraits.*

Drawing a well-known person adds a nice challenge because everyone knows what they look like. Plus, while we may well want to honor our fellow artists, we might feel our skills are not on the same level as the artists we've chosen to draw. It's true that they might not be but we can still be who and where we are. That will have genius in it.

In making art, we're always facing challenges and we can *practice* our approach. We needn't think too much to begin but just dive in. First, we can make some blind contour drawings of our chosen artist then contour drawings. As Picasso pointed out, inspiration finds us at work. We practice to discover our way forward.

Next we'll work with whatever materials we choose. We can follow the inspiration that comes to us which will be different for each of us. There's no need to fuss though. We can simply use paint or pencils, if we'd like to. When it comes to our own art, we can make more considered choices about the way we want to work. But here, in our club, we can simply explore and get ideas.

When done, we can look at the portraits together. Even though we're drawing well-known artists, we're bringing ourselves to meet them. Even when two of us are making portraits of the same artist, and taking the same approach, the results as we can see in the two examples on the following pages will be unique.

NB Our fellow artists are our friends—the great ones and the fledgling ones too. Working together, we get a lot of ideas. Our job is to discover *who* we are and what our special gifts and insights are. What way of working excites us? Having limited talents or skills is not necessarily a drawback as it forces us to find unique ways to create excellence.

Charles Studen—opaque watercolor drawing of David Hockney

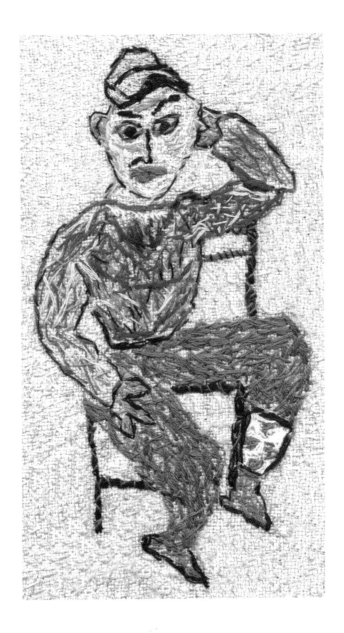

Maggie Stern—stitched drawing of Matisse

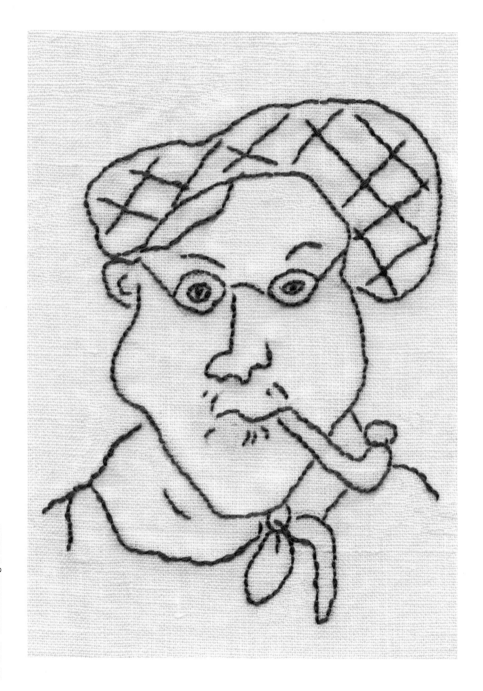

Week 6: Exaggerate

Materials: 11"x17" paper. Pencil. #6 and #12 brushes. Tin of opaque watercolors.

TIP: *When we exaggerate elements in our drawing, we can bring clarity to our art. And we'll get lots of ideas for what more we can do too. Check out David Hockney's more recent portrait paintings to see how he made use of exaggerated color.*

When I took my first drawing class, the teacher looked at my work and said, "All you have to do now is exaggerate." He was making the point that in the early stages of our development we tend to be cautious in our effort to get things right. "Just stretch out!" he said. "Play things up and everything will become clear." I wish now that I could remember his name because, ever since then, whenever I've felt stuck in a drawing, I return to that concept and it always helps.

What to exaggerate? The placement, sweep and strength of our lines. Shapes, color, composition. We can simplify in radical ways or embellish excessively. We can draw big or make tiny drawings. We exaggerate to find our power, and clarity, and to say something. Often, when we play with exaggeration, we see more.

We can ask ourselves a great question: "What if?" What if we do the same drawing in two different colors, one on top of the other but slightly skewed? What if we draw with a thick brush? What if we make the face green? We can train our minds to *look and see* what's there in our drawings in order to see what *might* be there if we push it in one way or another. What do we really want to say in our drawing? We may only sense it when we exaggerate and find answers.

For this exercise, draw anything you like, from life or imagination. If you're stuck, select a photograph of a person. Start with warm-up contour drawings. Put some music on and let these drawings be a meditation, a chance to simply explore. Once you have an idea, dive in. Try different things out. Ask good questions and follow inspiration.

NB Art is poetry. We can say what we want. We are truth tellers and explorers of great mysteries. Art encourages us to cultivate an open mind. We can stay open to new explorations and understandings. Being an artist encourages us to be fully alive and curious. It's practice in opening the mind to possibilities and truth.

—opaque watercolor brush drawing

—opaque watercolor brush drawing

—opaque watercolor brush drawing

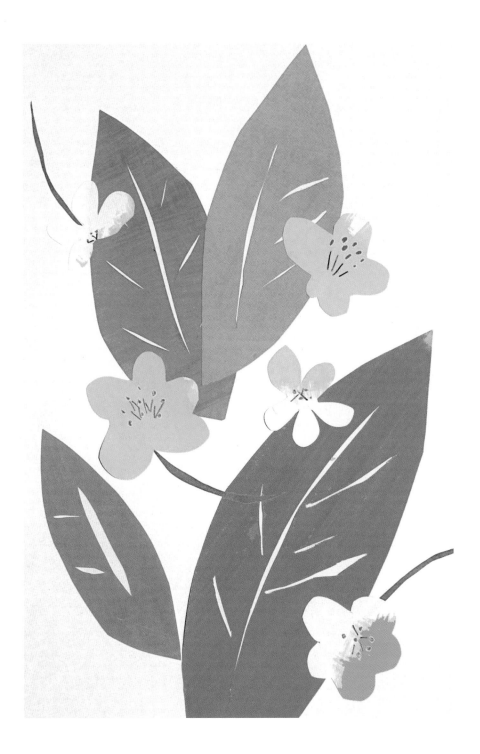

Week 7: Working Together

Materials: Drawing paper. Pencil. Brushes. Tin of opaque watercolors. Colored pencils. Scissors. Glue. Or any other supplies that suit your ideas. Nature, objects or photographs to work from.

TIP: *In making art, the process can be different for each of us. We may begin with a clear idea or discover it in the making. Working together, we can experience each other's way of working which may give us ideas for our own approach.*

In this exercise, we'll work with a partner to make an image. In the example here, we decided to work from nature and began the morning by going outside to find material, in our case, spring blossoms. We'd just emerged from a long winter so we were excited by how beautiful spring blossoms are.

We decided to use paint for our image. As noted, drawing often slides into painting and even collage. We began by working on our own. My partner began by using watercolor. I was making rough sketches in colored pencil at that point and hadn't decided yet how I'd proceed. My partner got to a place of feeling stuck so we looked at what she'd done together. She felt her initial exploration was pallid and didn't convey the excitement of spring. What could we do to convey forceful spring energy and also render the delicacy of the blossoms?

I had the idea to punch things up by using a cut paper technique. We had painted papers on hand and grabbed colors without fussing much and began each cutting the shapes out. The actual blossoms were white but we found a lively yellow and were able to make use of that. My partner got the idea to draw the stamens of the blossoms in colored pencil and add the free-floating stems to some of the blossoms.

Suddenly, we had an image and we were both pleased. I wouldn't have approached this exercise in this same way on my own and neither would my partner. But together, we found a great way to convey the joy we were feeling at spring's arrival.

NB This is more an exercise in the study of creative process than it is a means to an end. It helps to be aware of our own preferred process and also to try working in new ways.

Sue Twombly & Cat Bennett—painted paper collage with colored pencil

Looking ahead

Week 8: Sketchbook Journal

Materials: 9" x 12" sketchbook.

TIP: *A sketchbook journal is a place for writing about ideas too.*

Today, we'll start a sketchbook journal in the club then carry it into our lives. Where we are today is different from where we were the day we began drawing, and where we'll be in ten years. Whether we stick with one form of art-making or explore in many different ways, we can use our sketchbook journal to continue to explore.

In the second session, we used a sketchbook to explore drawing and art-making. We can use our sketchbook journal to draw, collect inspiring images, reflect and make notes so that we might discover more and more what we can do. It's an *idea-generator* and when we work in it, ideas come. Inspiration is a higher form of thought and, as Picasso pointed out, it often finds us at work. We can work in our sketchbook journals—reflecting, planning and designing. The key is to act *immediately* on inspiration, whatever it is, without hesitation. One thing leads to another, one person to another, one idea to another. Our sketchbook journal opens the door to the studio and can take us into the world too.

So, first, let's note where we are today. Just jot it down. What are we doing in our art right now? What inspires us right now? What do we want to do? There's no need to break into a sweat over this, just quickly take note. Then, let's see where we go.

Today, go out as a group, sketchbook journals in hand, perhaps to a café, or a museum or into nature. Draw whatever you like, things you see, things that come to mind, what interests you. Or simply draw what you see and consider the way you are drawing. Then write down what you might do next to further your ideas.

Something vital is trying to catch our attention and draw us in. Our art journal can help us see what it is and make something of it.

This is a good point to remember that life is meant to be fun. We're working from the inside out, from the joy and peace drawing can give us. We make art to share our insights and being.

NB The brilliance of art isn't just what we make, but what it makes of us. Art takes us where we've never gone before and helps us entertain all sorts of dream.

—colored pencil and watercolor drawing

18 Carrying On

"The power for creating a better future is contained in the present moment:
You create a good future by creating a good present."
—Eckhart Tolle

• • • • •

Three sessions are not enough, of course, for a drawing club of improbable
dreams. Our club is ongoing. Over time, some of us will find other ways to forward our
journeys. Some of us will stay on; some of us will come and go.

To carry on, we'll need to invent new explorations. Every exercise in each session
here can, without difficulty, be stretched out for eight weeks. For instance, we could
draw in an abstract way for the whole eight weeks and develop our own internal logic for
evolving our drawings each week. We'll get ideas from our friends and think more deeply
about our approach.

We could draw in an abstract way too, and change it up each week by using
different materials, for instance. One week charcoal, the next crayon, the next black paint
with a 2" wide brush, the next finger paint, the next watercolor crayons and so on. We
could make a deep study of mark making, and we would also be discovering how marks
make meaning. We might discover how we make our drawings coherent. We might notice
what happens when we think less and let go of control. This is a deep and subtle study.
Inspiration comes when we're working.

There are other ways to vary and deepen an exercise. We could again take the
example of drawing in an abstract way and change the scale each week. We might go from
huge to tiny to huge to medium and so on. What does that feel like? What happens?

We could also take the same exercise of drawing in an abstract way and make
sequential drawings that we turn into artist's books. Perhaps we'd draw for two or three
weeks, then we'd select drawings that might tell a story of sorts, adding new drawings
when necessary to tell the story we want to tell. We could have these books bound or learn
to bind them ourselves.

The exercises here are mere starting points. Let's recap what we've done.

The first session concerns itself mostly with skill building. We can build our drawing skills in so many ways. Any kind of practice will contribute to a sure hand, and a sure hand helps create a stable thinking process. One thing isn't separate from another. Skills matter. They allow us to grow our art and not be hemmed in by uncertainty. But even with fledgling skills, we can make beautiful work, if we bring our attention to it. We're are on a journey and moving forward, always.

Other things we might consider are hiring a model at times or going as a group to a life drawing class at an art school or adult education facility. There are plenty of such drop-in classes in most cities. Or drawing outside in nature or in cafés or at museums.

In the second session, we pushed drawing into different forms such as painting, collage and monoprint drawing. Again, within each of these exercises we can create many variations. We might paint only with line, or not use line at all. We might paint in washes or solid forms. Or we might simply practice and hone our skills. As The Saturday Morning Drawing Club has progressed, we've returned to many exercises, often with a variation of some sort. The more we practice, the more ideas we'll get.

In the third session, we tried doing ordinary things in somewhat extraordinary ways so as to come to know ourselves as artists better and to grow our intrepid spirits. We want to ask good questions. What are we doing? What's emerging? What happens when we exaggerate and push our ideas? Can we see more? Does it open something up in us? Who am I? What do I want to do and share? For each exercise, we can invent many others. Our club is a constructive art think tank.

The exercises here are just starting points. As artists, we move from one awareness to another. We can struggle to gain traction. It's normal but making art will lead us forward.

The Drawing Club of Improbable Dreams is an art in itself. We're continuously inventing new ways to explore, expand our visions and empower ourselves as artists. When we work together we get lots of inspiration and a chance to heighten our energy too.

19 Back to the Studio

"Because I cannot work except in solitude,
it is necessary that I live my work and that is impossible except in solitude."
—Picasso

.

Now, back to the studio. We need some alone time to make our art, but it's not a lonely affair. Once we're engrossed in what we're doing we feel a kind of oneness, as if we're part of something bigger, and we are. And, of course, we'll need to nurture our social selves once we're out of the studio, as Picasso did. In fact, the Paris of Picasso's day was perfect for artists, with its cafés to which they all flocked in the evenings. Fun and conversation, friendship, good food, perhaps a glass of the grape, all can enhance our hard work and enrich our lives as artists. We can grow our friendships with artists, collaborate in many ways and nurture each other. We are more together than we can be apart.

Let's also note that we can make our personal work anywhere. Nice as it is to have a designated studio space, it's not necessary. Some superb artists work on their kitchen tables. And let's not forget Van Gogh, slaving away in his bedroom. Wherever we choose to work, or are able to, we can organize around that. Not having an ideal space shouldn't hold us back, neither should having an ideal space. Wherever we are, we need to sit down to work. Doing something every day builds our energy.

Art can give us a real sense of purpose. It can be a way of exploring life and what we can make of it. Its special gift is that we get to give something of ourselves to the world around us. What we do with this sense of purpose can change over time. Sometimes raising kids is going to take precedence, or running a business, or having a job, but we can still keep our hand in. We'll know if we're getting the balance right by how we feel and we can make adjustments as we go. We want to feel *good*!

We've made all kinds of explorations in our club. Depending where we are in our art journeys, these may or may not play a vital part in what we do when we return to our studios or kitchen tables. We'll likely have new ideas and more experience. We may well have grown our sense of adventure and courage, both so necessary for making art.

Wherever we work, we want to keep our good energy as much as possible and engage with inspiration. In our club, I look online for artists that might inspire us and often print out a sheet of images each week that will give us ideas about how other artists approach what we're working on. We can do the same in our studios. We can also continue to work with our sketchbook journals. It may also help us to keep some of the work we've done in our club meetings to see where we've been and what we can do. They can give us ideas.

If we're beginners, we can start with what we *most* want to do. One thing leads to another. If we're more experienced, we'll already have a body of work or a way of working we prefer. We can follow whatever inspiration comes to us in this moment. Everything we've done will inform our journey forward. We work from the inside out. There will almost certainly be struggles and uncertainties. In those moments, which can last a while at times, we can choose to nurture ourselves by sharing what we have with others, perhaps teaching or offering school visits, reading about art, visiting with fellow artists and visiting galleries and museums too. And simply drawing.

We can decide how much or how little we want to work at our art. Cy Twombly said he worked in bursts, whenever enough steam built up and he felt like it. It would be hard to imagine making such energetic, large-scale works, as he did, working every day. They have such spontaneous energy in them. On the other days, he said he often looked out at the sea or read poetry. What a great life! Other artists will work in more disciplined ways, putting time in day after day. We can find what suits our temperament and our way of being in the world. It may well change as we go forward, as most things do. There's no rush, no need to get anywhere but where we feel we want to be in this moment.

For me, art is also a meditation, something I want to do often, even if sometimes just in a simple, unambitious way. It offers me a sense of deep pleasure and presence, and a place to simply *be*. I love thinking about it and exploring. I like to ask what's possible. After years as an illustrator of daily toil, I now feel like Cy Twombly in this way. I'm always looking around and thinking about art, and life, and I'm living too. Then inspiration comes—some irresistible idea, some burst of energy, and I sit down to work. There's a rhythm, like waves, but we're never far from the sea.

Our club is our social place of investigation and support, an energy builder, and a place to reflect and discuss. Our studio is where we make what we're going to make.

20 The Improbable Dream

"Always go with your passions. Never ask yourself if it's realistic or not."
—Deepak Chopra

• • • • •

Once, in the very early days, when our portrait skills were still rudimentary, we all set out to draw the Queen of England. It was her birthday and so it seemed like fun. When we all draw the same thing, we add a subtle challenge. Will one person make a better likeness than the others? Or perhaps everyone will do a great job except for one of us. Working publicly in a club is so different from working alone where no one needs to see.

In the midst of this exercise, one that held the robust challenge of making the Queen look both regal and human, there were a few anxious sighs. How could we do her justice with our fledgling skills? I, too, wondered. Perhaps we'd jumped over the cliff too soon. But there was also the faint whiff in the room of a rather gallant bravery. We would soldier on! After more than an hour of scratching away, smudging, erasing, looking and making one more mark, many brows were furrowed. Then, a sudden guffaw slipped from one of the members. "Oh, my! What the …!" She let out a screech of laughter. "It's so off! It looks nothing like the Queen! Nothing at all!"

We all murmured mild assurances though we couldn't really see yet what she'd done. Surely, our drawings were not so bad, at least. What a relief! We had that assurance when we strode up to the wall to hang our drawings together to look and see, and find what's good. It only took a moment. And the great good on that day was that *every* drawing was way off! They *all* had awkward misses—a nose askew, eyes too close together, oddly pursed lips, strange hairdos, teeth like piano keys. It was as if we were meeting the Queen in person and simply falling apart, uncertain of our manners or what to say! The drawings had that degree of awkwardness. Some were closer to the mark than others, a little. But none came close. Not one. We all laughed. To me, it was one of the best mornings of our time together. These drawings brought more happiness than getting it "right" possibly could have.

—blind contour drawing of the Queen of England (with apologies)

That's not the point though. The real point is that on this day, when nothing went right, we could laugh. We could totally accept ourselves, and each other, just as we were in that moment, and without hesitation. How beautiful is that!

We've learned so many things together. How to draw with more assurance and adventurousness. Yes, we have done that. Progress has sometimes been slow and we've each had to learn patience and perseverance as we've worked towards strengthening our skills. It does seem improbable now that *everyone* has learned to draw. But what I love even more is that each of us has learned to draw in our *own* way, to just be *ourselves*. And as we grow, our work continues to evolve.

Can we all draw the Queen well now? We tried last week again and came closer, I think, yet still missed the mark. Some things remain a challenge and some challenges don't need to be met. The more we draw, the more we learn to forget our "perfect offering" to simply be as we are, which, as it turns out, is perfect and often so moving. We've come to see that art is less about accurate *rendering* and more about our insights and sensitivities, our courage and willingness to be who we are. Better yet, we've discovered we each do *something* superbly well.

Almost all of us have shown our work. Several of our members have had individual shows and sell their work in various ways, including the one who felt afraid she'd never learn to draw in our very first session. She and another member had a duo show after a couple of years of working together. Another, who also hadn't drawn since childhood, now sells her work in The American Museum of Folk Art in New York City and many other venues. Quite an accomplishment! It's been a privilege to witness all of this.

But there are other things, equally fine. It appears that, in our time together, we've learned to be more present, more able to focus. What we do is so much greater when we can bring our whole selves to it. Something comes to meet us—the creative energy all around us. Focus requires a kind of mental discipline, a willingness to let niggling thoughts and distractions go and to always return to what we are doing. Drawing can teach us this focus and it makes all the difference. We're less demanding of results, more curious about possibilities. Less closed, more open. More available to tap dance on a table in a crowded room. We're just here, enjoying the ride.

Our one rule has changed things too. In looking for the good, we can now see the value of simply letting go of judgment and overevaluation when they appear. Those

demons have undermined us all. But we can distinguish now between discernment and old habits of judgment. We've learned to give ourselves a pat on the back and know how it helps, especially when things are hard. We know how to act immediately on inspiration and don't need a rubber stamp of approval to move forward. We can step out from where we are in the direction of our dreams.

I see that desire matters way more than talent. It's desire that brings us to the drawing board, day after day, and desire that urges our hearts to speak. Our most tender offerings can have great feeling in them.

In drawing and sharing our work together, we can be very vulnerable. We change when we shed our cloaks of self-protection though it's harder for some of us than others. It can come for each of us, drawing by drawing. The road ahead is unfolding and every step matters. When we accept each other with our tender failings and our successes too, we take longer strides. Our best learning is in mistakes; it's good to make big ones.

I think we're each still looking to make something sublime, in whatever way. Art keeps asking that of us and maybe it's why we love it so much. Sometimes we find what we're looking for and then we start to dream again. That's how it goes.

I'm thinking of the Queen and how we laughed that day. How we were and are *one,* not just the members of our club but all of us. There are seven billion people on the planet at the moment and so much peril. With so much to overcome, can it really matter if our drawing of the Queen is off? But think of this: what happens on paper is one thing; what happens in our hearts is so much more. Gandhi said if we want peace in this world, we need to first find it in ourselves. If we want to find creative solutions to the challenges in this world, we need to know how to be creative thinkers, how to focus and persevere. We need to know how to be open-minded, to discern rather than leap to conclusions, and to know the values that serve all of us, not just some. We need to know courage. Art is our teacher. It brings us forward into our true strength. Our wobbly drawings, the ones we've made together, have trained us to face our uncertainties and find a way forward no matter the difficulty. What if seven billion of us made wobbly drawings?

It's my dream that many more of us will find ourselves in a club, drawing together, one exercise at a time, becoming more and more who we truly are. Even that seven billion of us will. When we draw together, great things happen. Happy drawing!

Appendix: Supplies

These are the basic supplies we use most in The Saturday Morning Drawing Club. The brushes are student grade. In doing our own work, we'll benefit from having professional-grade supplies, especially brushes, paint and papers. But, for the purposes of our club, we don't need to fuss too much but know that lines are finer with good brushes and color more vivid on good paper. It's not necessary to get everything on the list, but we'll need paper, pencils, charcoal, paint, brushes, scissors and glue sticks to start. Rather than gather a lot of supplies to start, it might be easier to get things as the need arises.

- Ebony or soft drawing pencils (4B or higher)
- #4 and #6 brushes (We use Princeton brand.)
- Tin of Pelikan opaque watercolors, 24 colors
- Vine charcoal, medium
- Stick charcoal, medium
- Jar of black poster paint or acrylic
- Jar of white poster paint or acrylic
- Large scissors
- Glue sticks
- Jar of acrylic matte medium for gluing
- Set of pastels (We use medium hard Prismacolor® NuPastel® Color Sticks and share a box with 96 colors. It's possible to buy replacement sticks.)
- Set of colored pencils (We prefer the rich colors of Prismacolor® and Dick Blick® brands, with 150 colors. It's possible to buy replacement pencils.)
- Ream of white drawing paper
- White card stock for collage work (Can buy in 100 sheet packs.)
- Hot press watercolor paper

Mo Cook—white-line woodcut painted with opaque watercolor based on pencil drawing

Thanks—

Without all the artists who have spent time in The Saturday Morning Drawing Club, I wouldn't have discovered the way working together grows not just our art but our good humor and grace too. I thank each of you. Very special thanks to Sally Young, who had the idea to hire me as a drawing teacher when The Arsenal Center for the Arts outside Boston first opened its doors. Your adventurous spirit and stalwart support have done so much to launch and sustain our club. Thanks also to Bev Snow, Program Director, who has been both supportive and good-humored about all of our requests. And to Aneleise Ruggles, Assistant Program Director, who brings cheer to our mornings too. Special thanks to Mo Cook, Barbara Epstein, Connie Henry, Carol Katz, Deb Kaup, Maggie Stern and Sue Twombly, early members of our club who have all made our mornings feel like a sanctuary of goodwill. And extra thanks to Maggie who kindly read an early draft of this book and offered such excellent suggestions.

All of the artists in the book are also members of The Saturday Morning Drawing Club. Thank you for sharing your beautiful work here—Mo Cook, Deb Kaup, Maggie Stern, Charles Studen, Karen Trittipo, Sue Twombly and Sally Young.

Much gratitude goes to Thierry Bogliolo, publisher at Findhorn Press, for publishing this book and my first two books on art as well. Your kindness, patience and hard work are extraordinary and so much appreciated, Thierry!

Matt Jatkola has been invaluable as Designer Extraordinaire and brought ease to deadline pressures. A true pleasure to work with. Thanks, Matt!

Deepest thanks to my husband, Allan Hunter, whose comments and insightful editing helped add new dimensions to the manuscript and saved you, the reader, from the many perils of my messy first drafts. I'm truly lucky to have such a partner in life.

Thanks also to all the readers of my previous books who have taken the time to write to me. I'm so happy that drawing is furthering your joy and appreciate all of your insights and kind words. They provided some fuel for this book too.

Finally, thanks to Leonard Cohen whose music so often opened the veins of feeling on Saturday morning as art is meant to do.

Previous books by Cat Bennett

FINDHORN PRESS

Life-Changing Books

Consult our catalogue online

(with secure order facility) on

www.findhornpress.com

For information on the Findhorn Foundation:

www.findhorn.org